THE ART OF MINDFULNESS

RELAXED AND FOCUSED COLORING

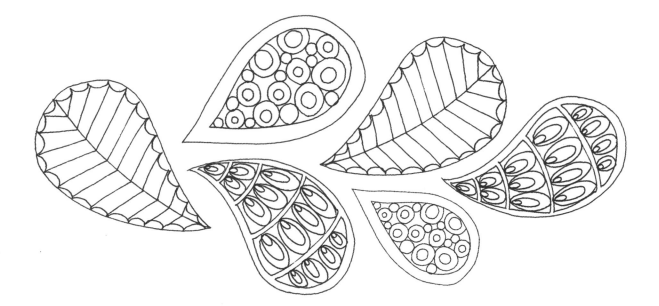

LARK

New York

New York

An Imprint of Sterling Publishing
1166 Avenue of the Americas
New York, NY 10036

First published in the United Kingdom in 2015 by Michael O'Mara Books Ltd., as
The Art of Mindfulness: Relaxed and Focused Colouring

© 2015 by Michael O'Mara Books Ltd.

Designed by Ana Bjezancevic and Claire Cater
Cover illustration by Lizzie Preston

Illustrations by Angela Porter, Angelea Van Dam, Carol Spencer, Cindy Wilde,
Emily Hamilton, Fay Martin, Felicity French, Hannah Davies,
Lizzie Preston, and Sally Moret

ISBN 978-1-4547-0961-9

Distributed in Canada by Sterling Publishing
c/o Canadian Manda Group, 664 Annette Street
Toronto, Ontario, Canada M6S 2C8

For information about custom editions, special sales, and premium and corporate purchases,
please contact Sterling Special Sales at 800-805-5489 or specialsales@sterlingpublishing.com.

Manufactured in Canada

8 10 9 7

larkcrafts.com

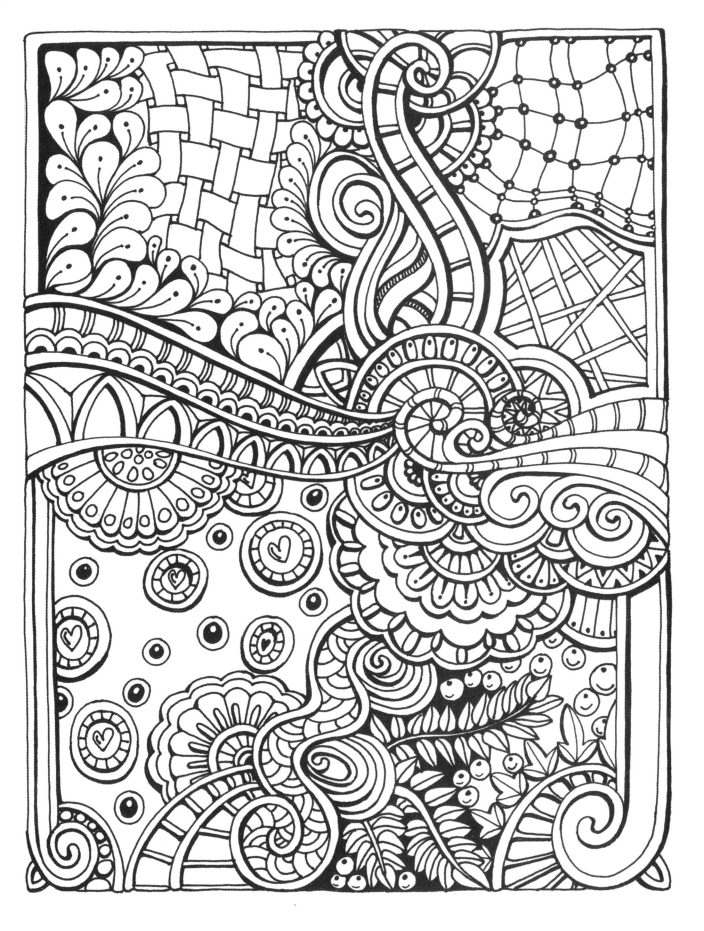

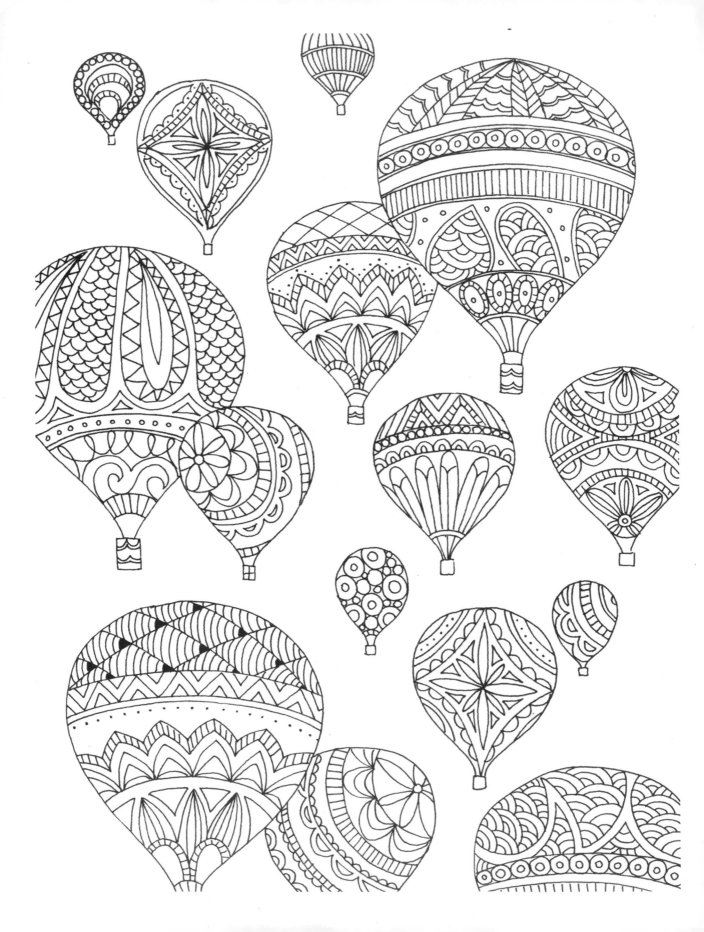

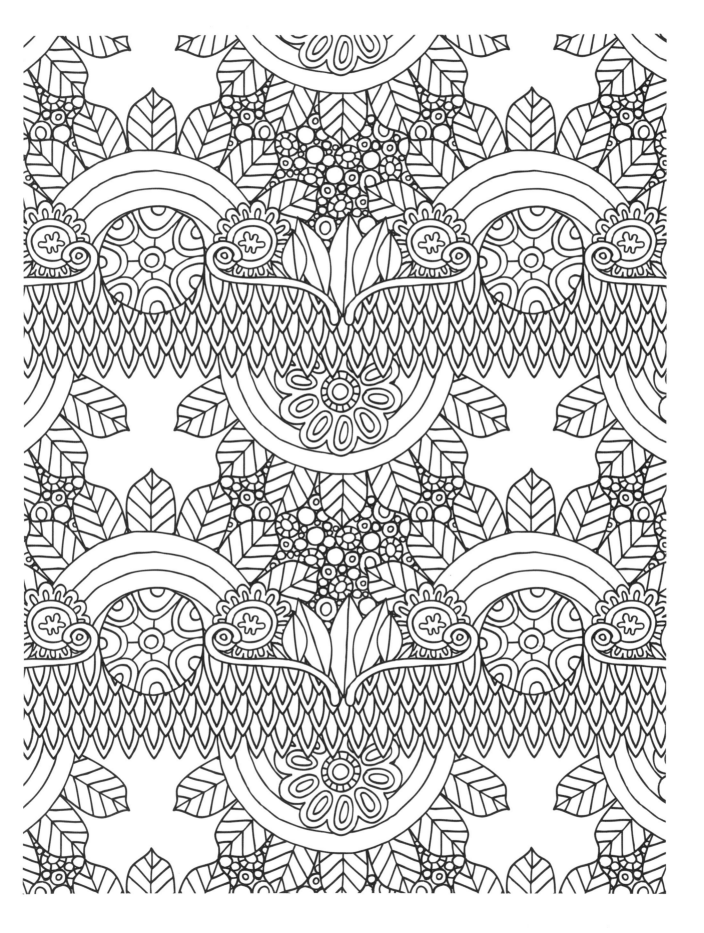

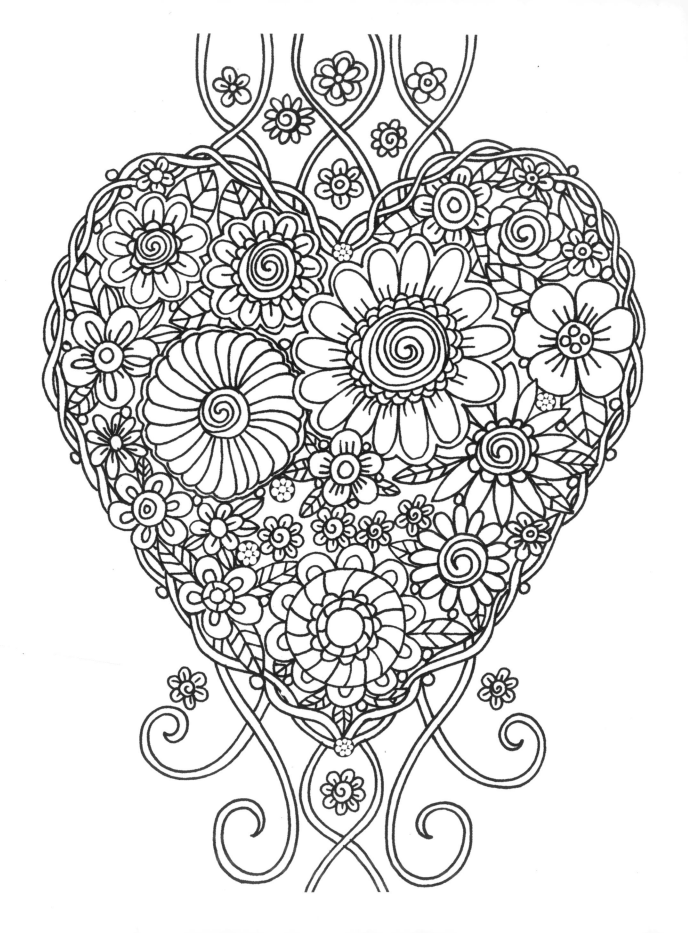

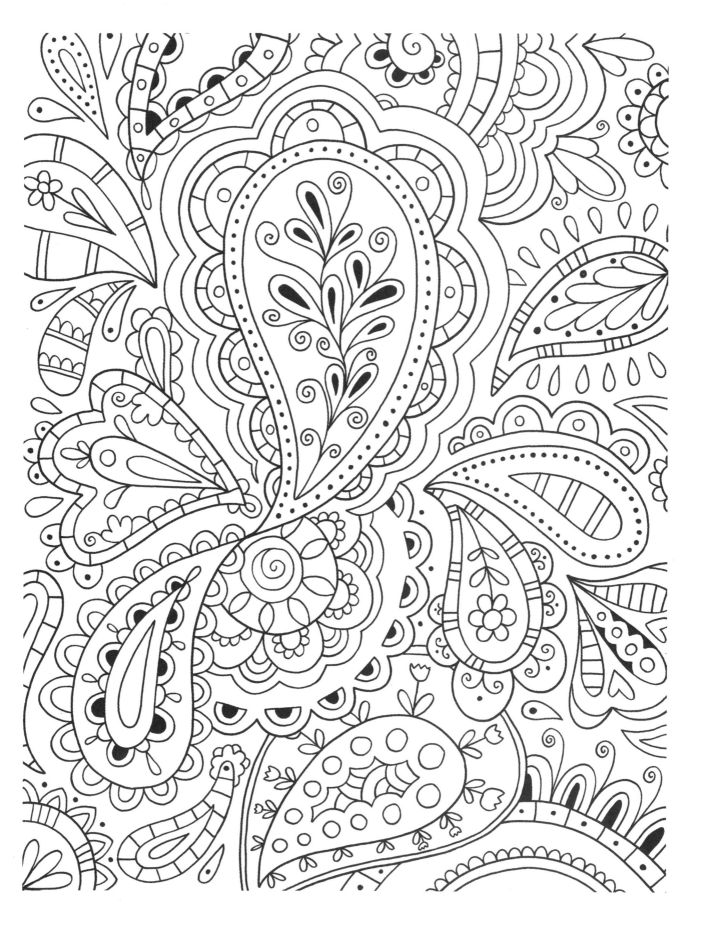

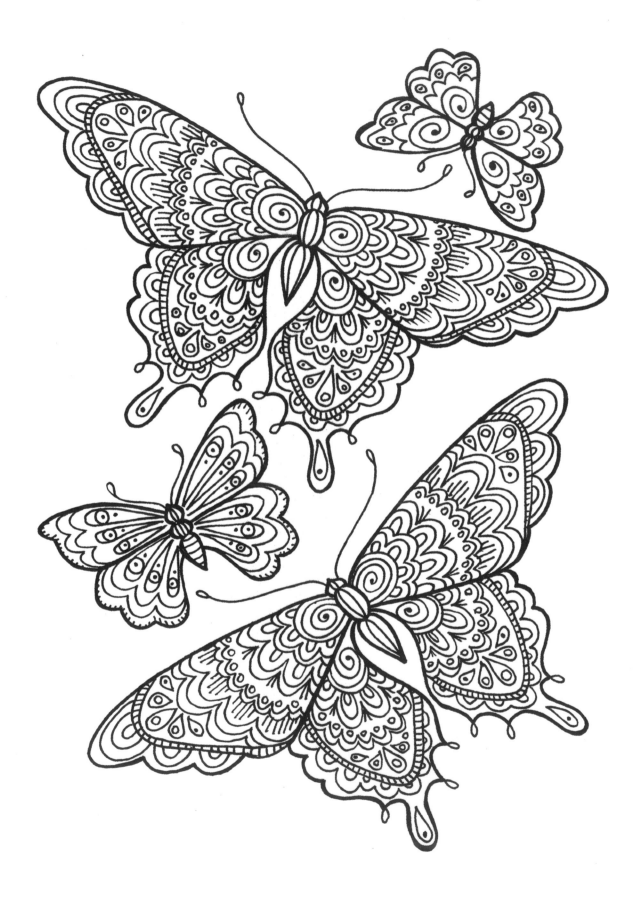

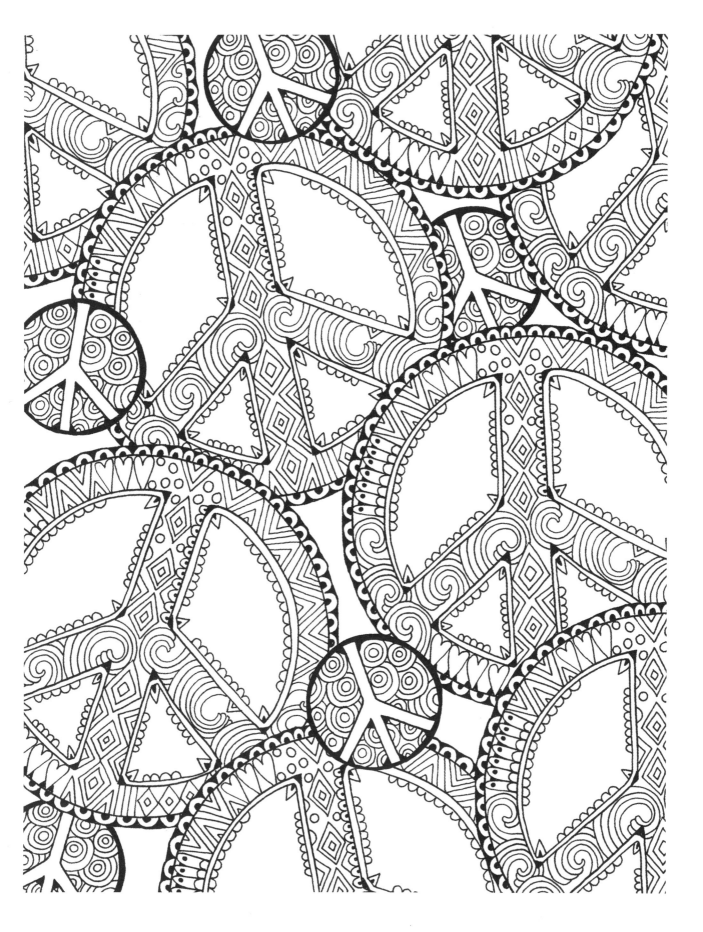

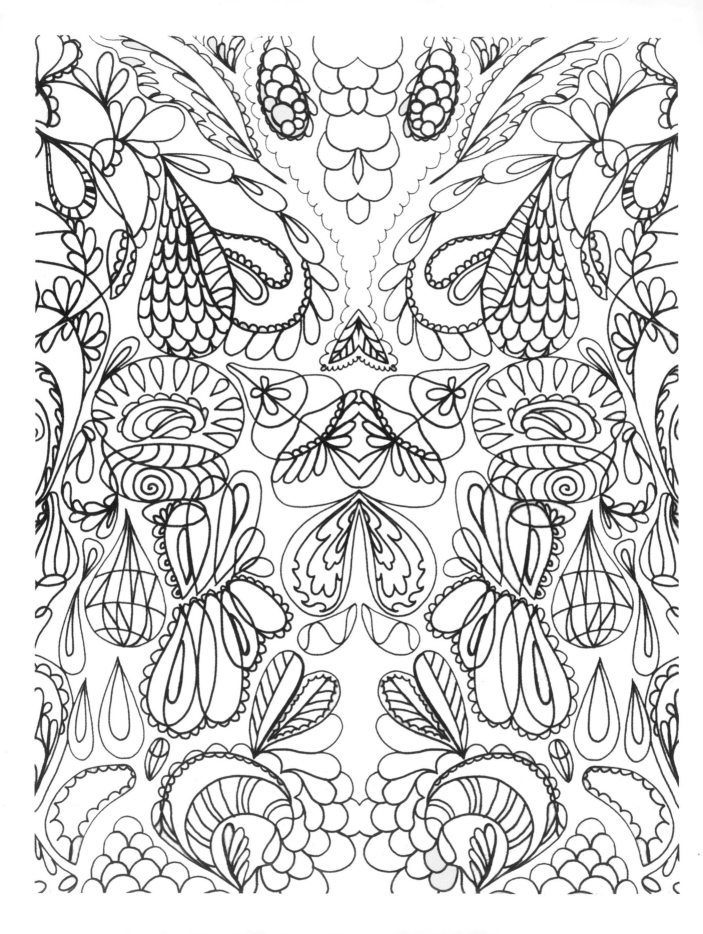

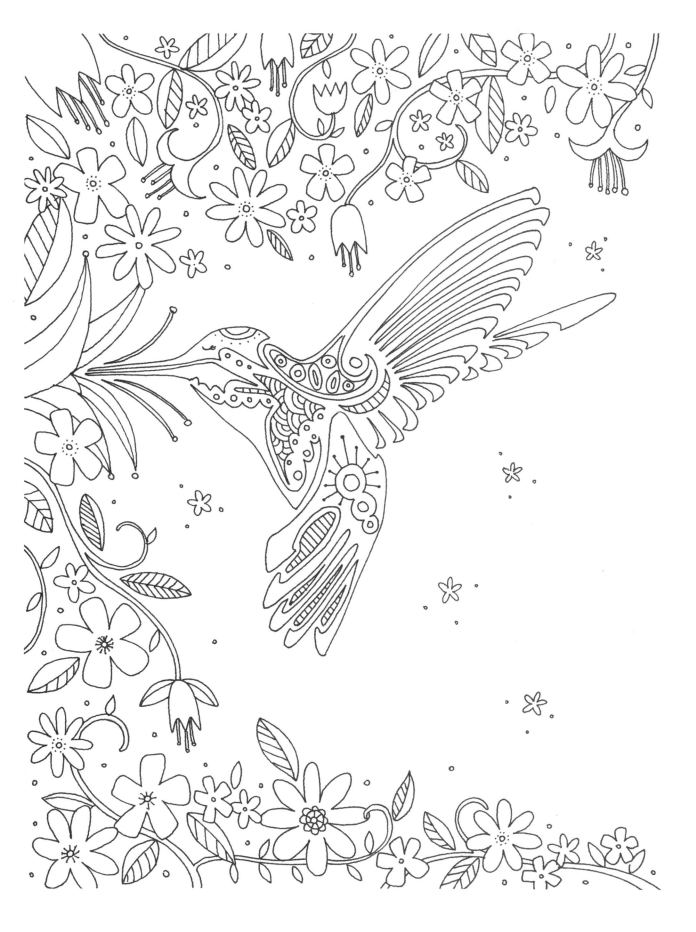

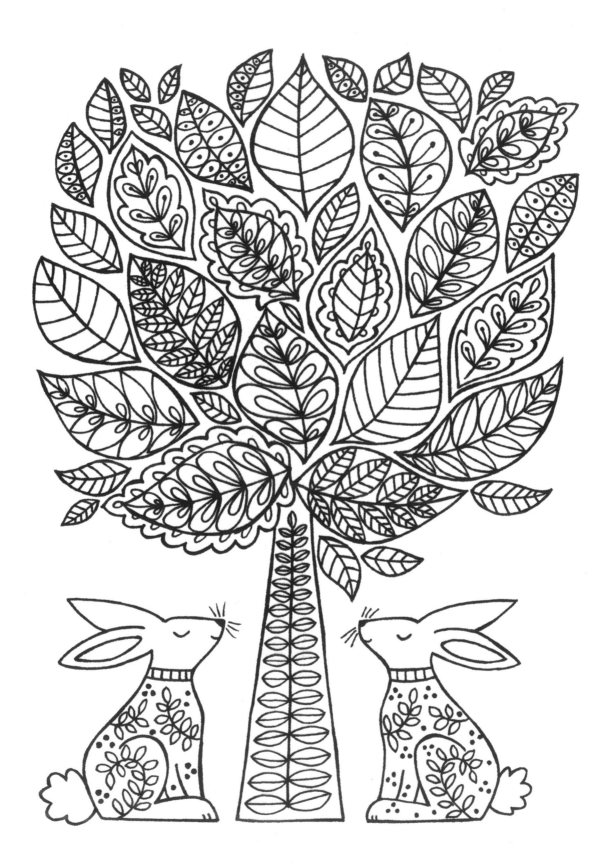

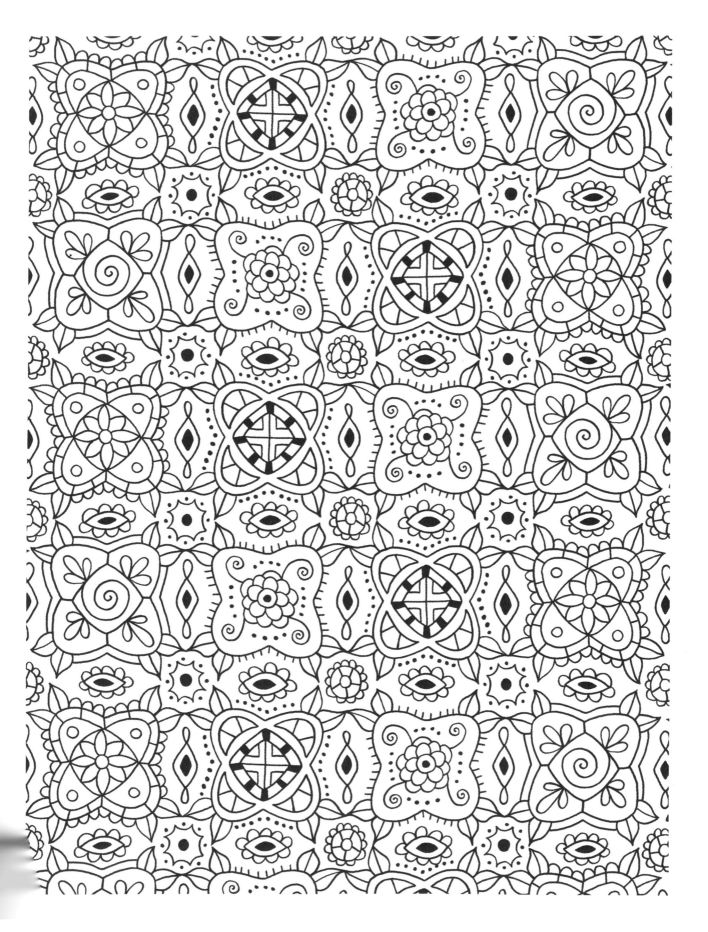

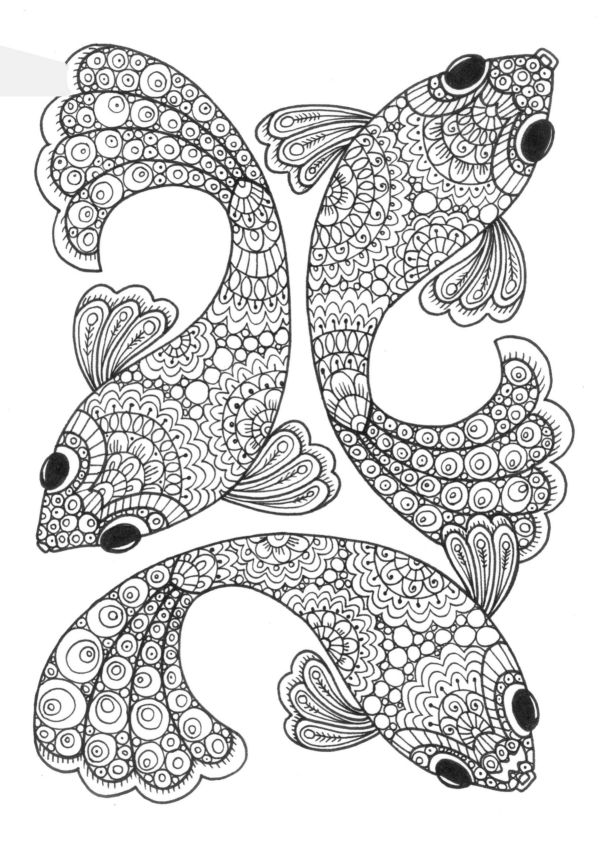

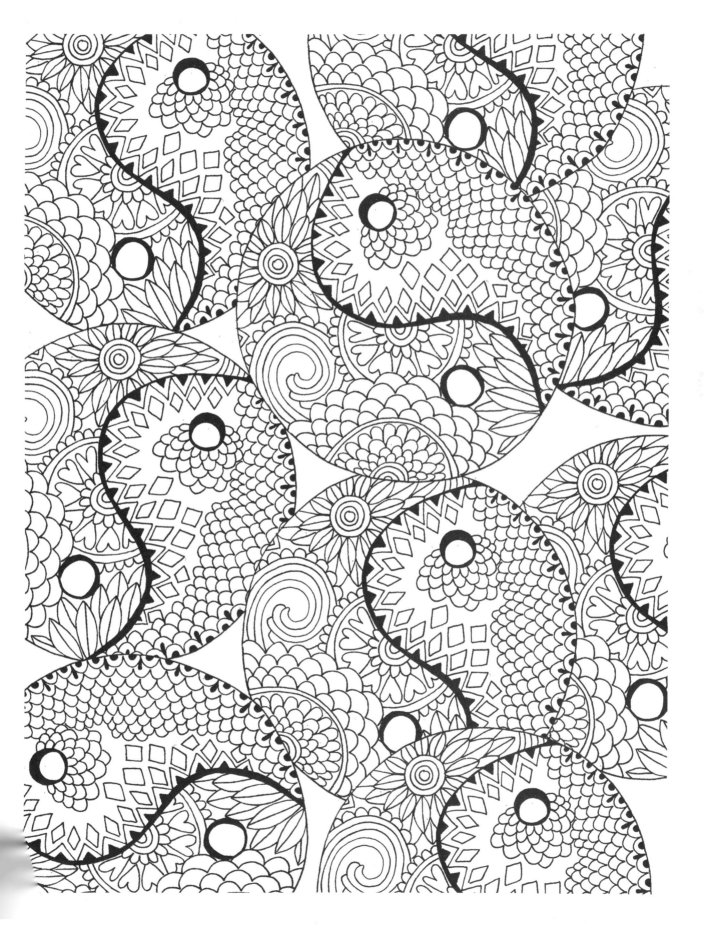

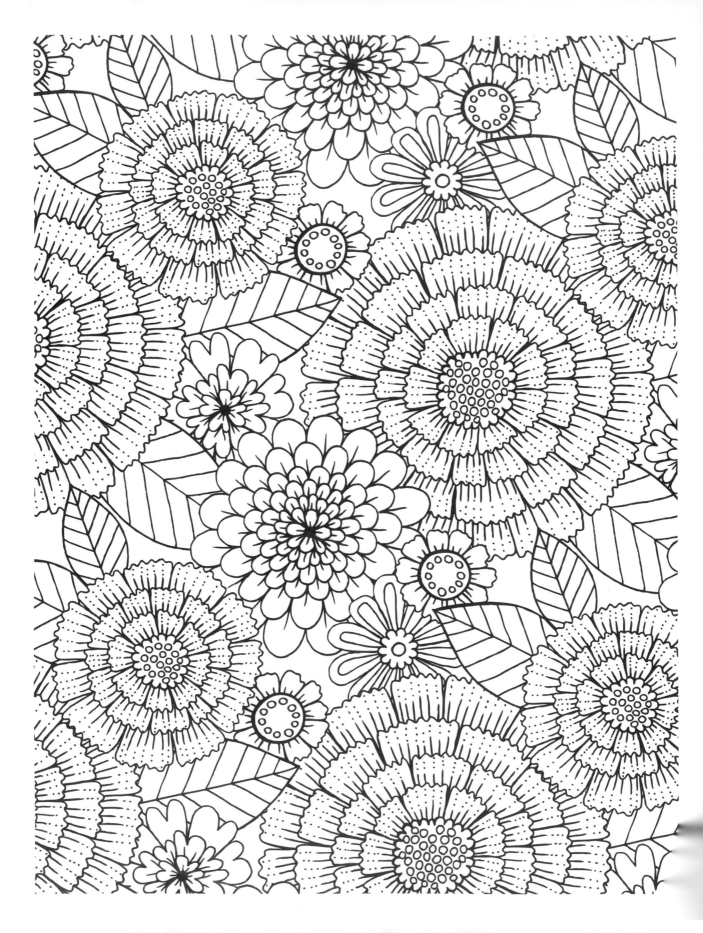

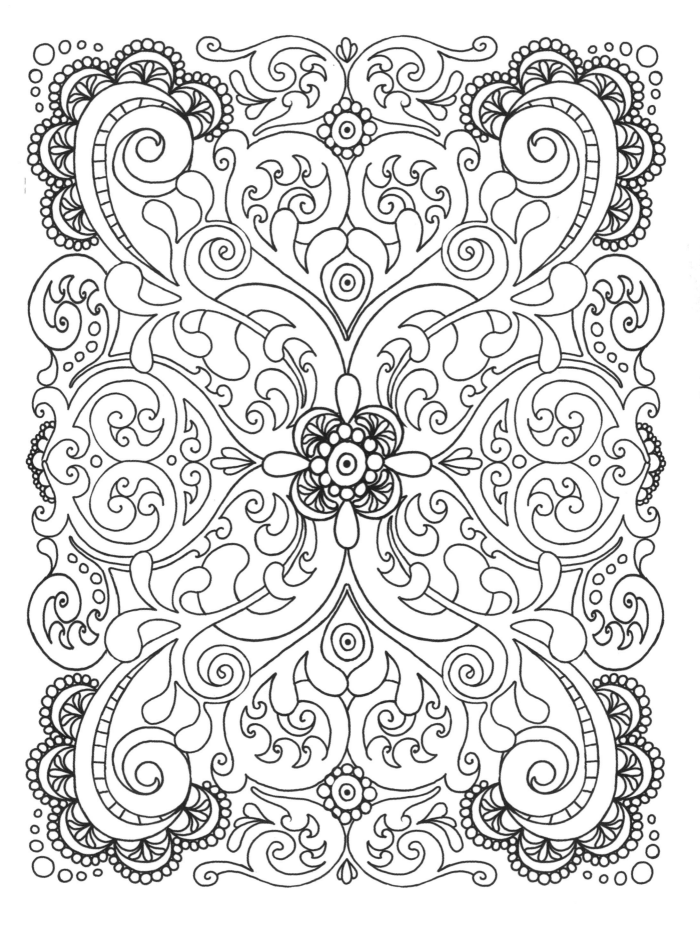

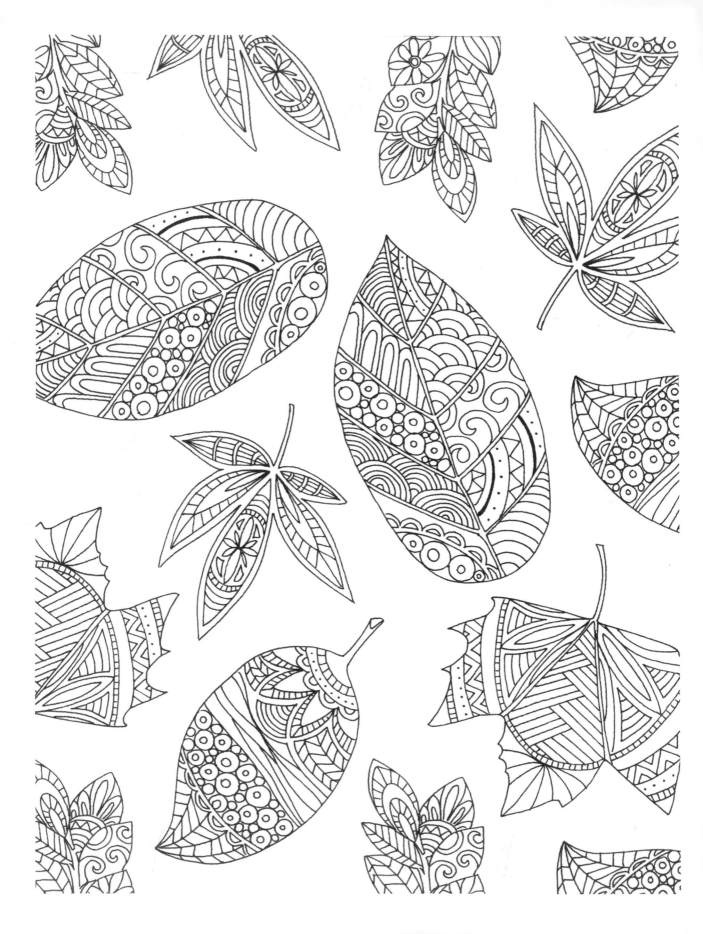

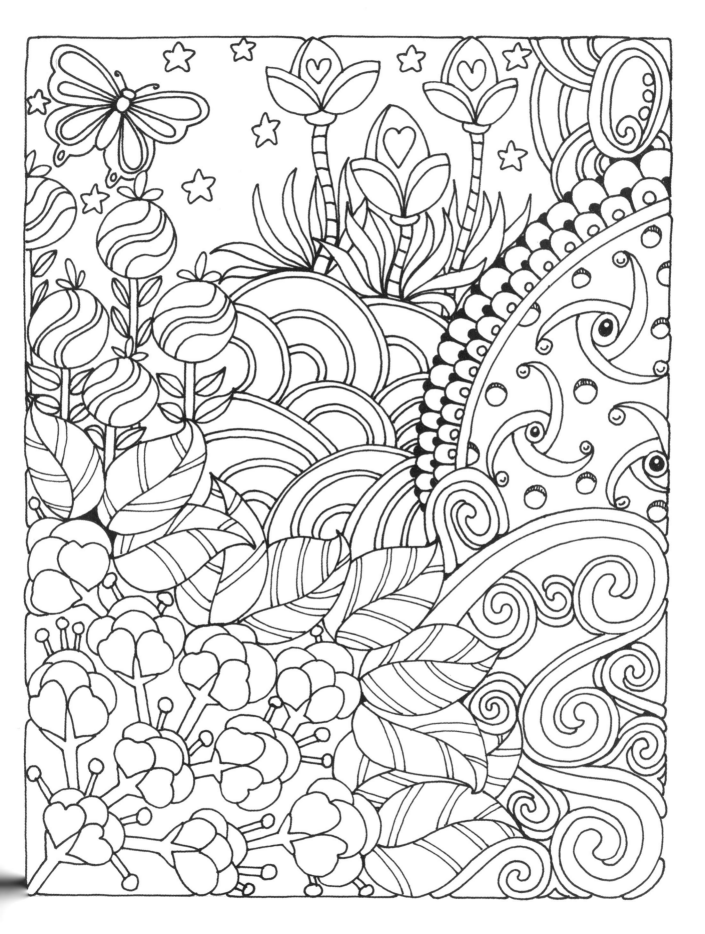

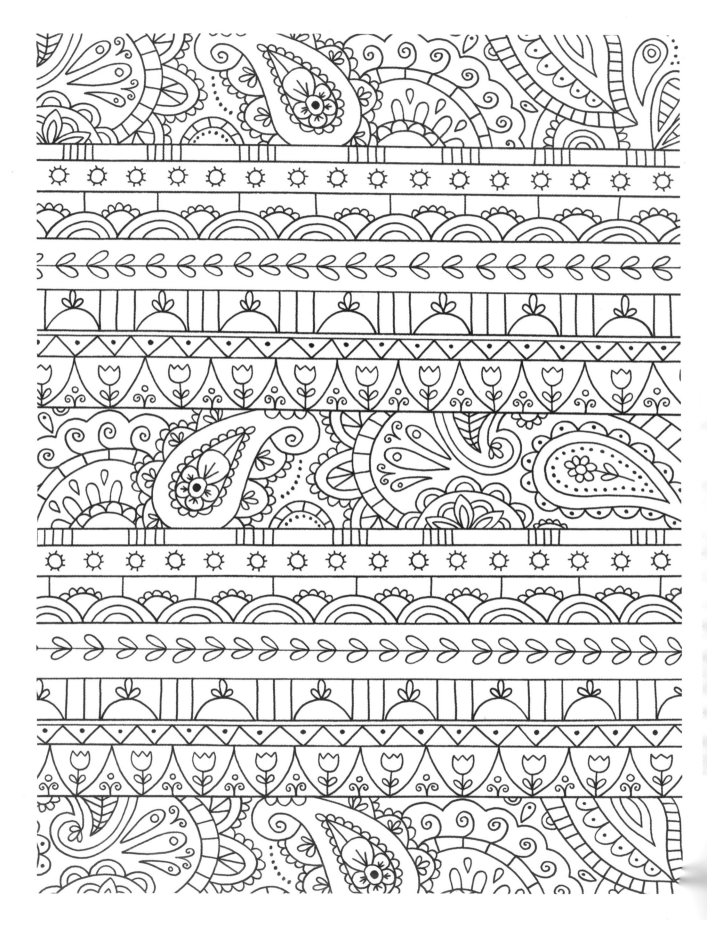

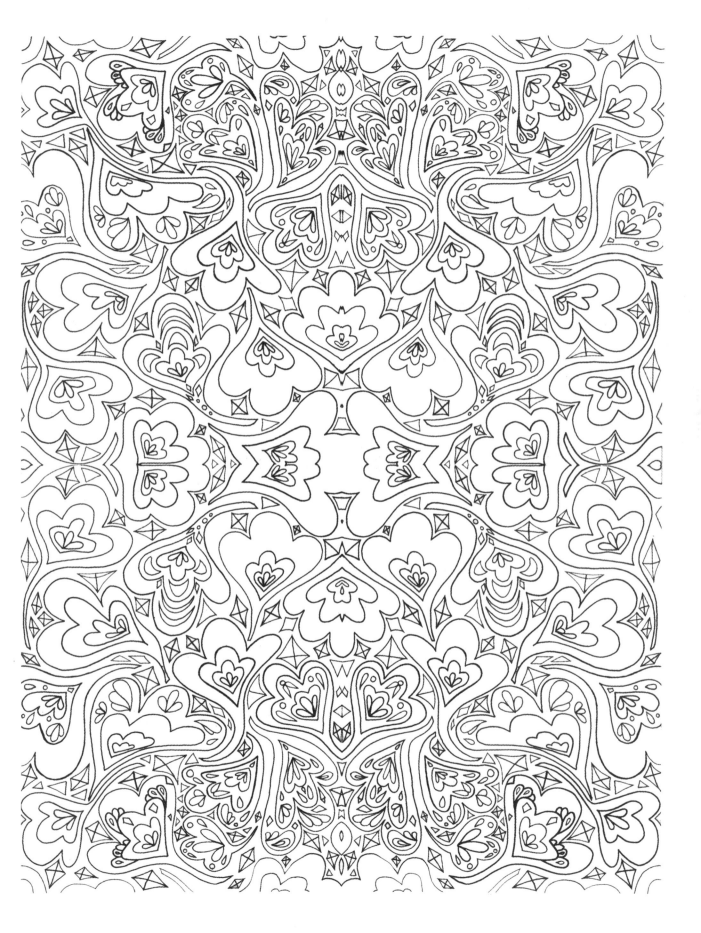

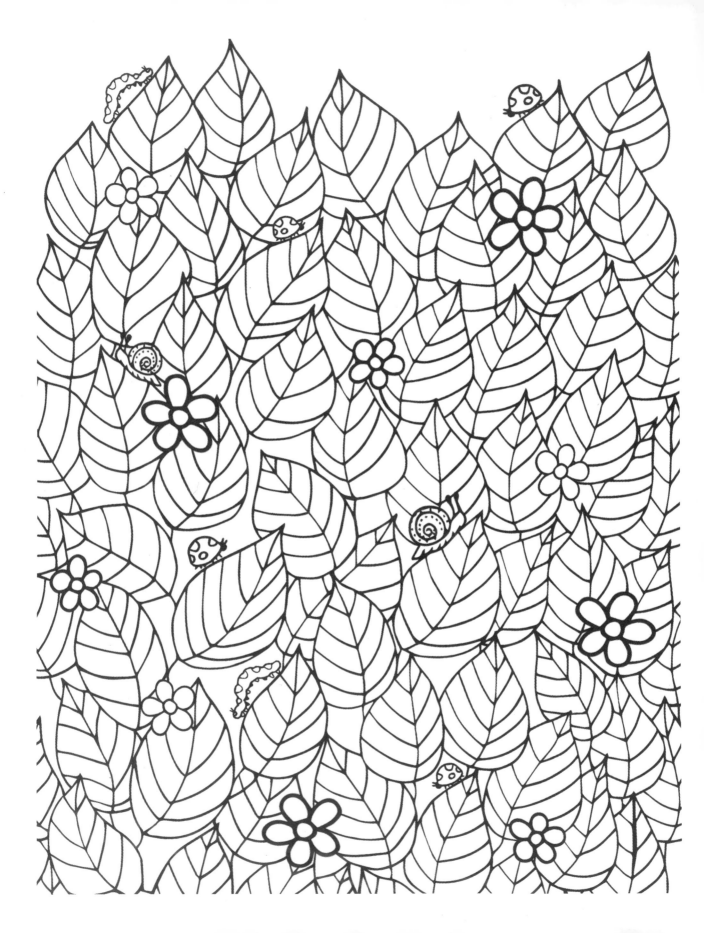

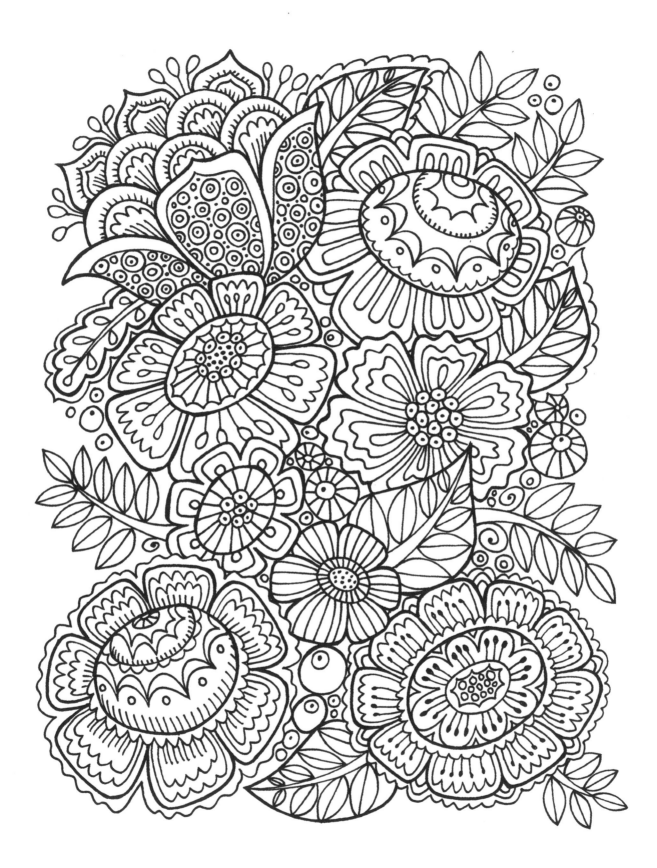

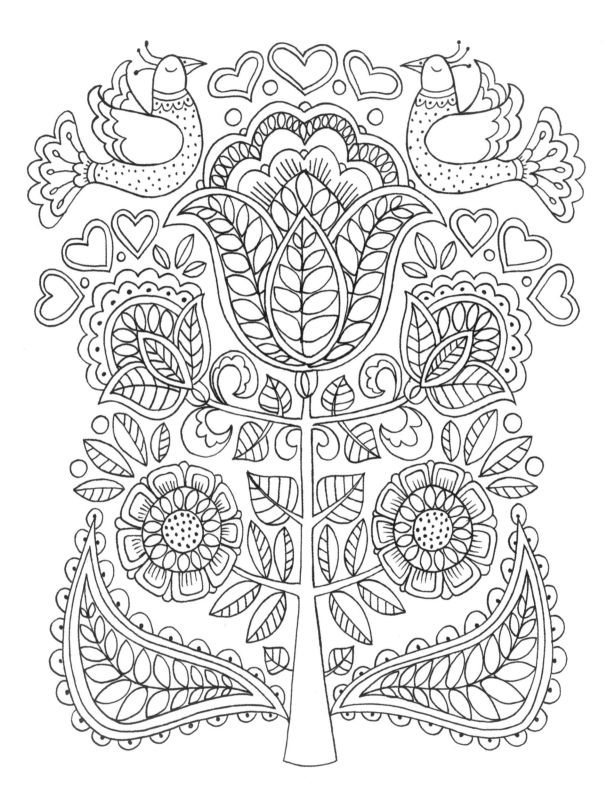

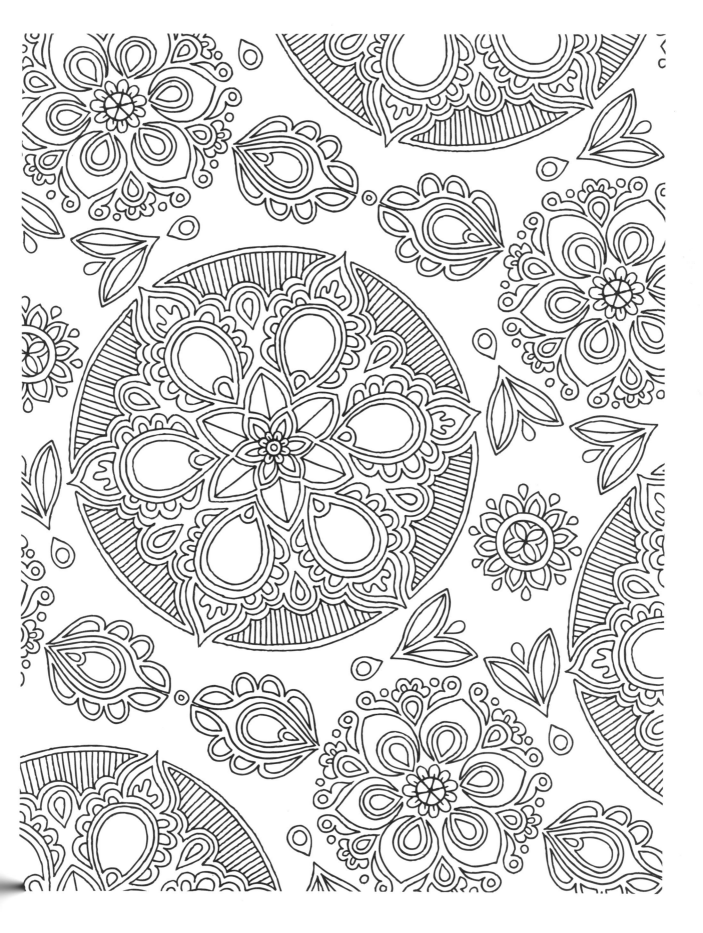

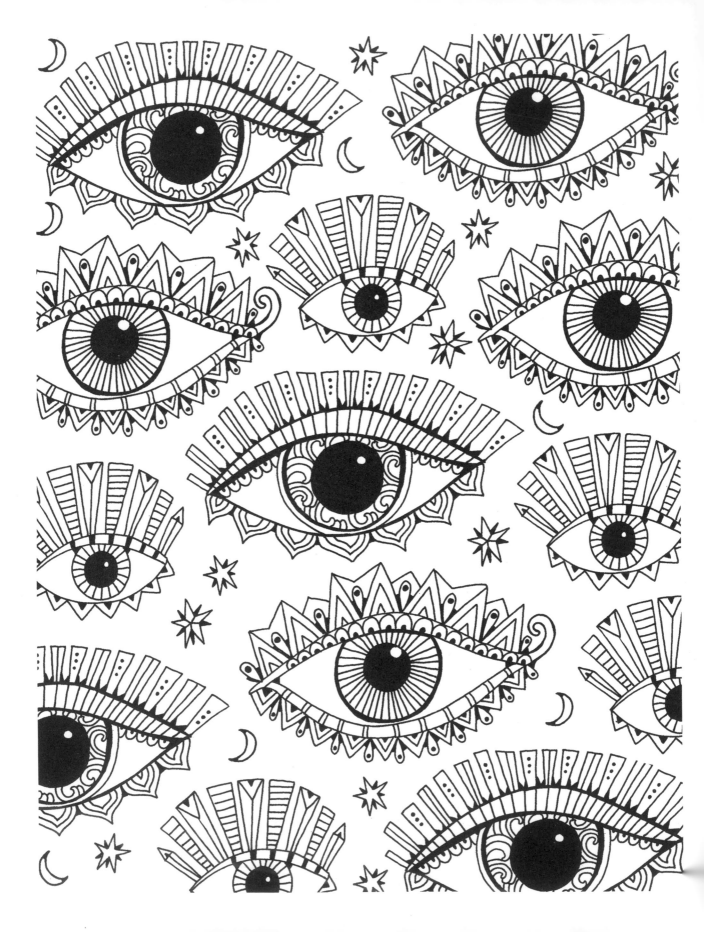

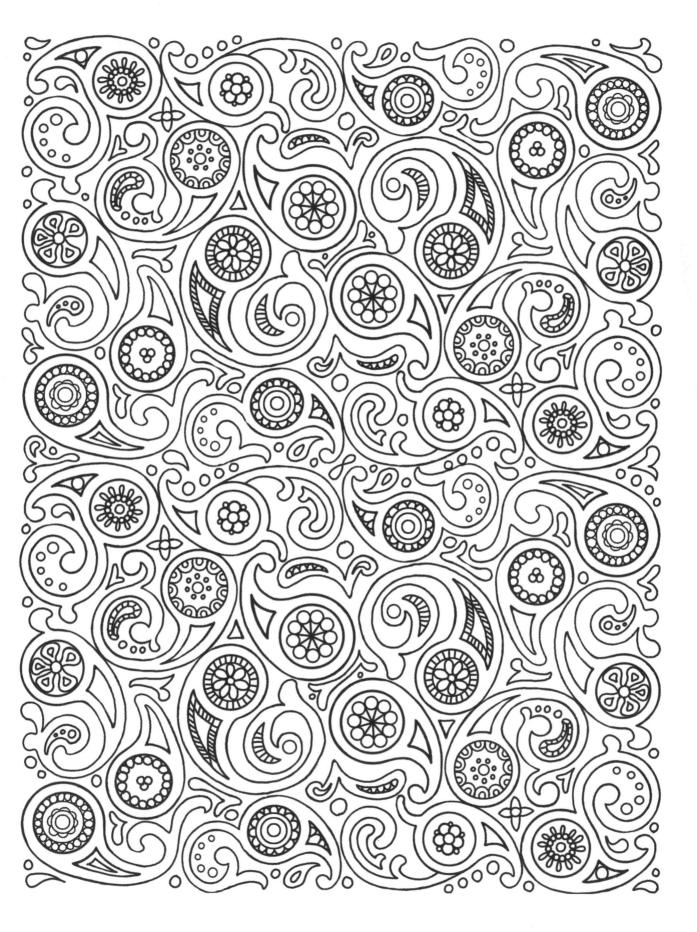

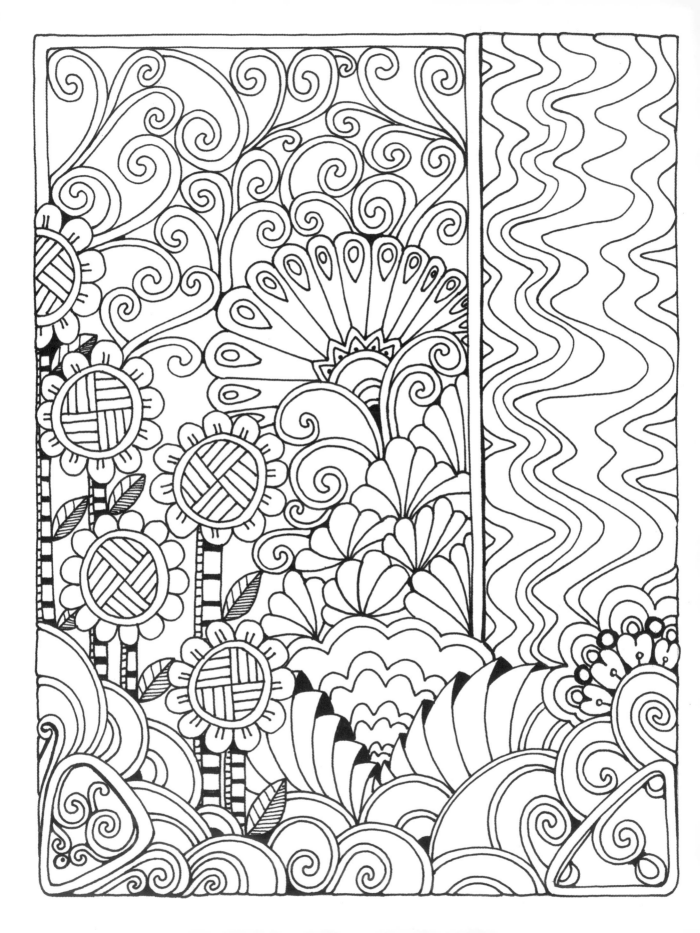

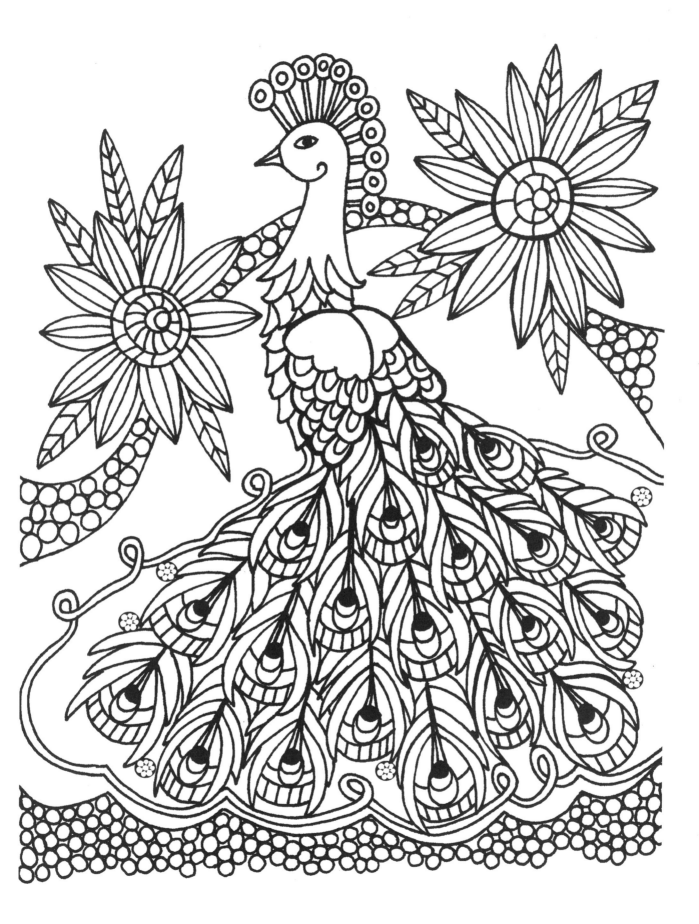

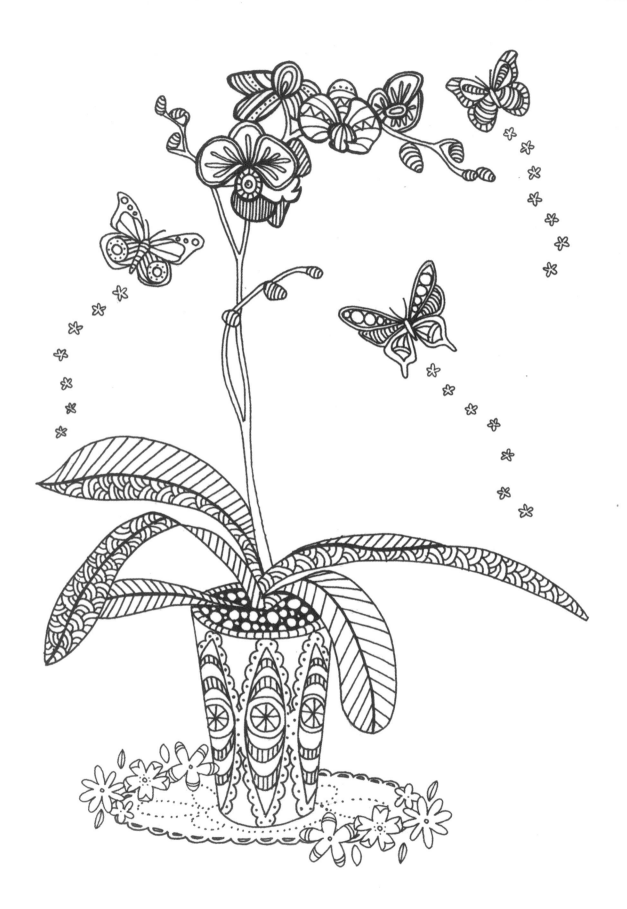

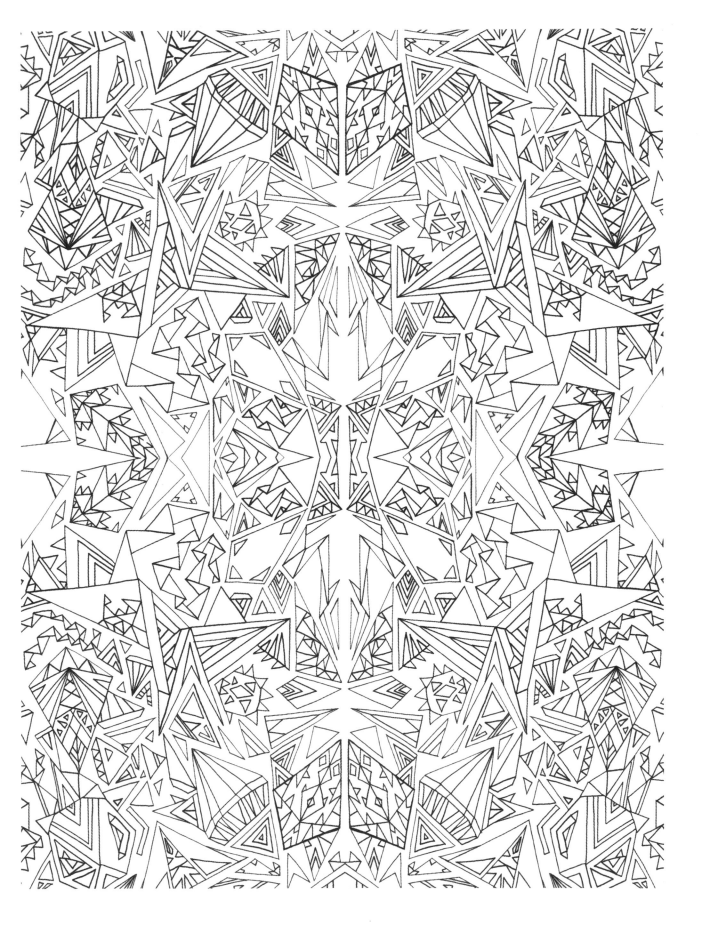

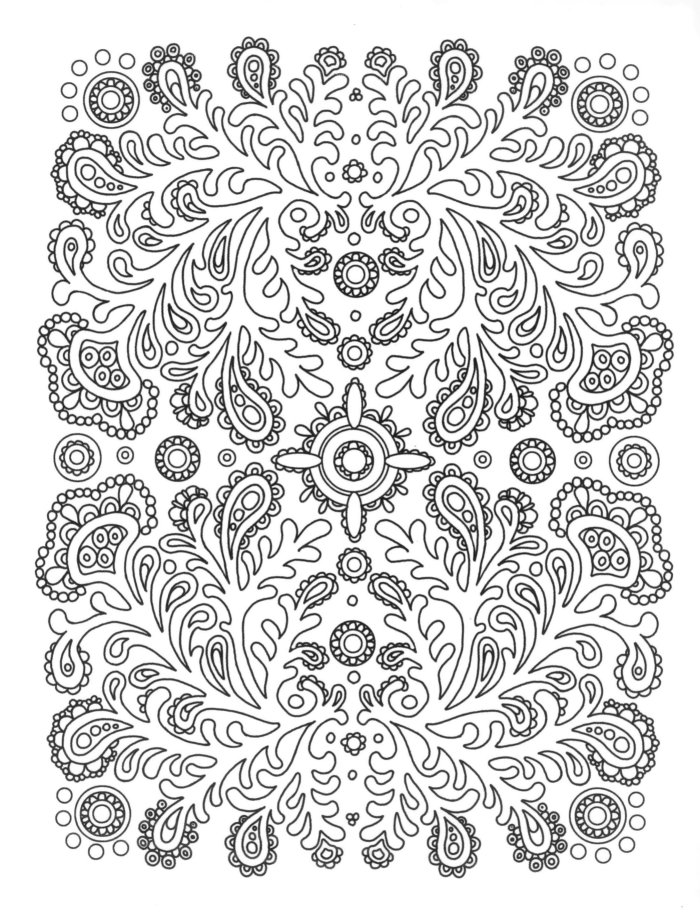

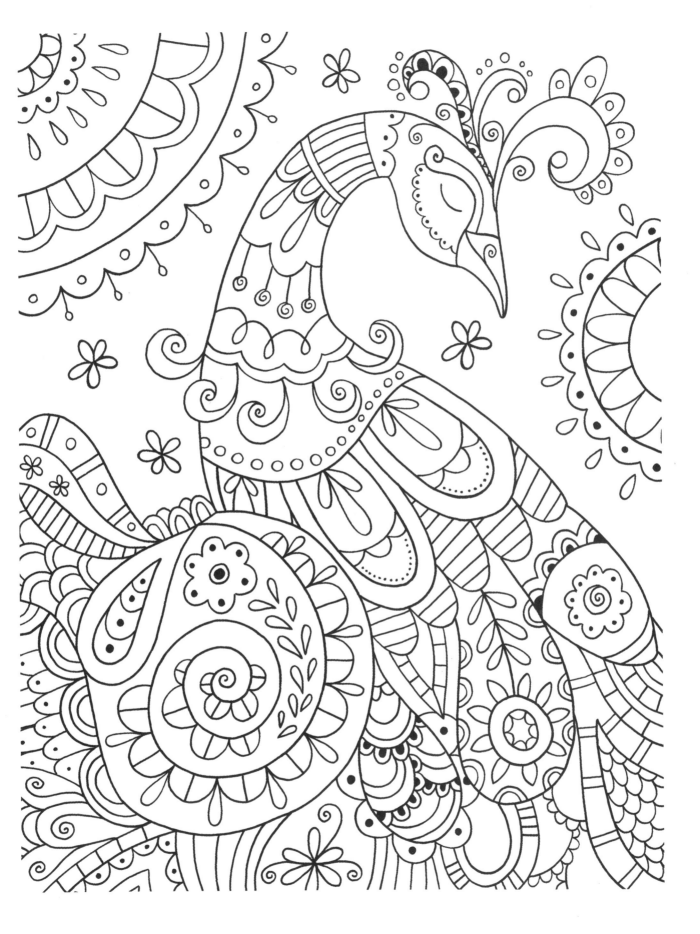

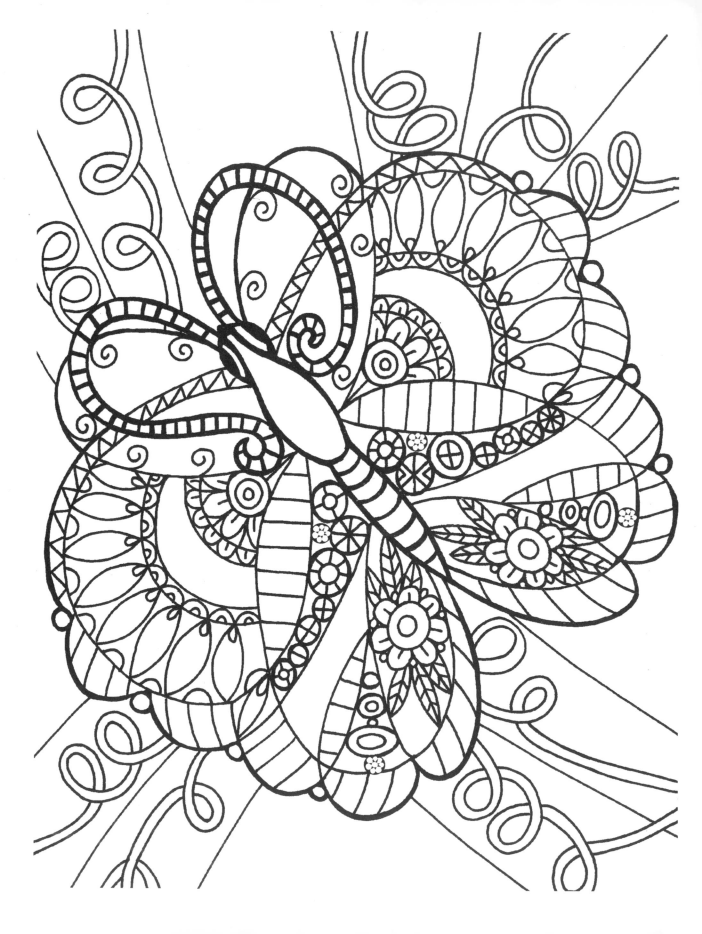

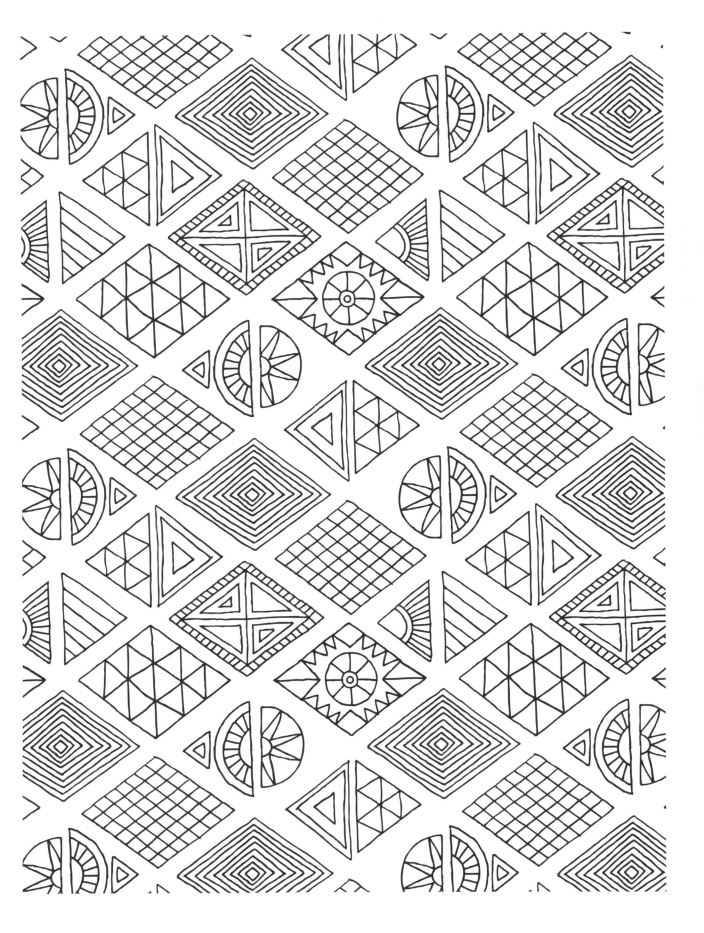

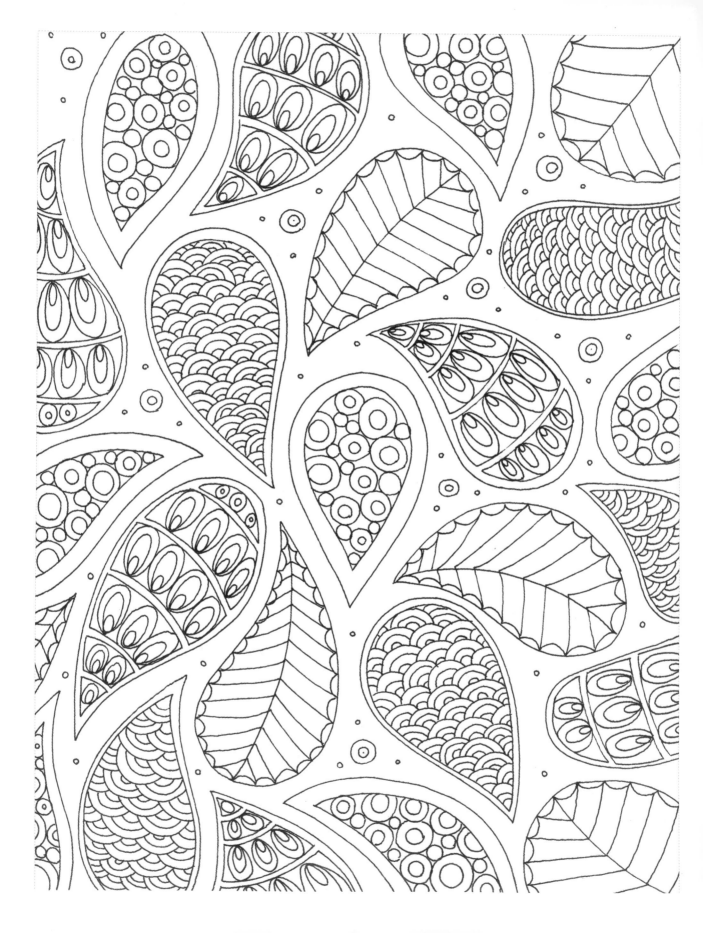

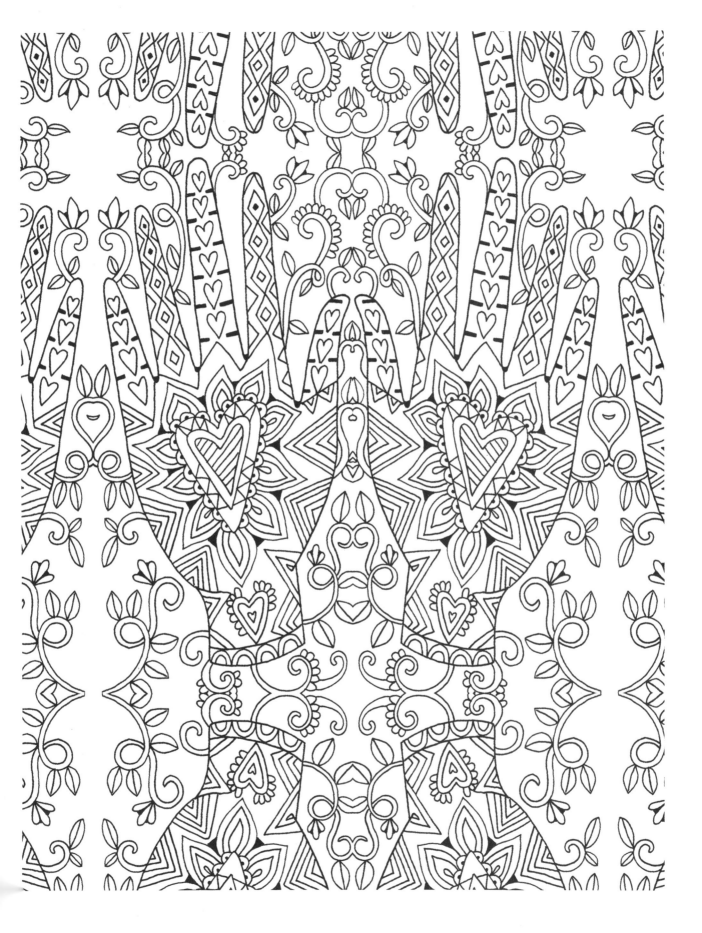

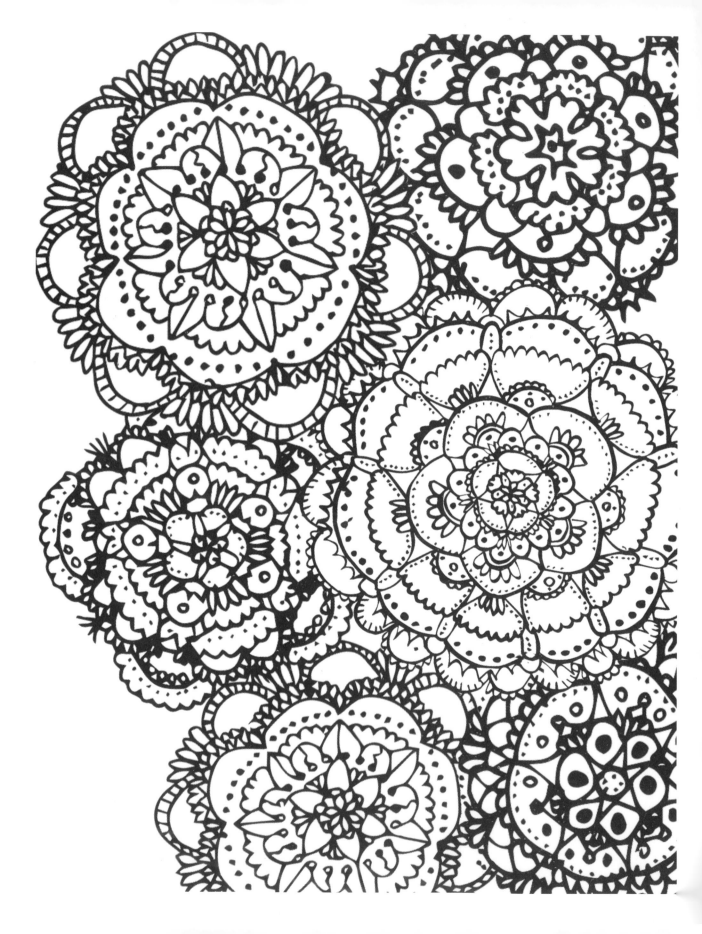

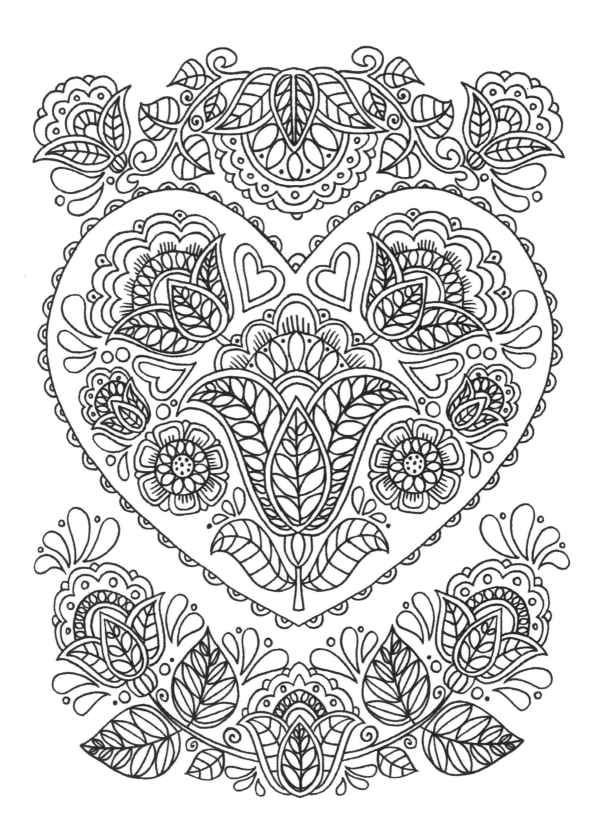

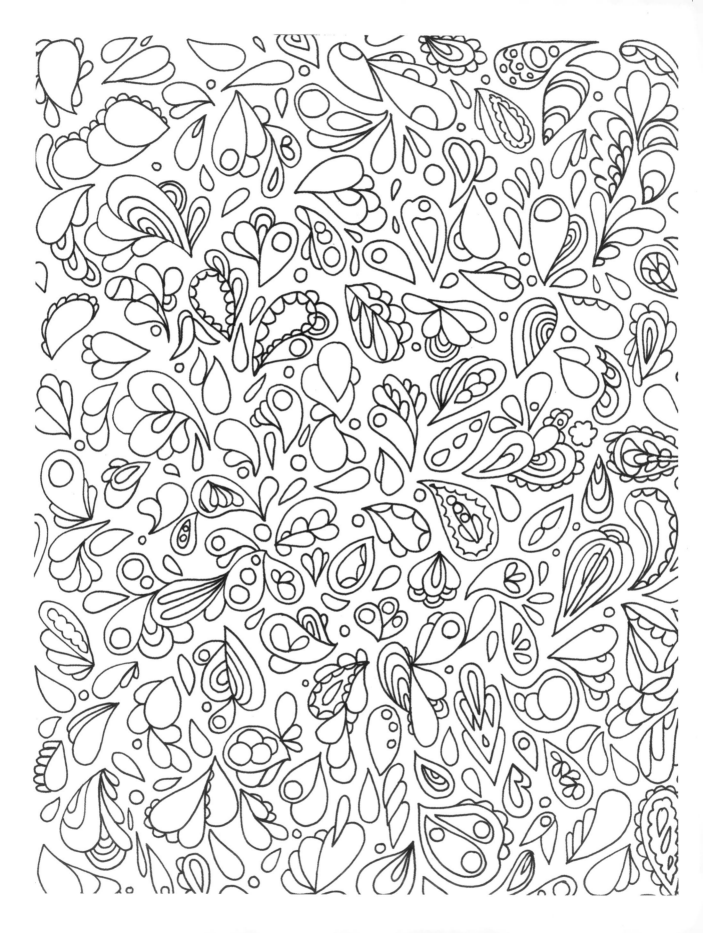

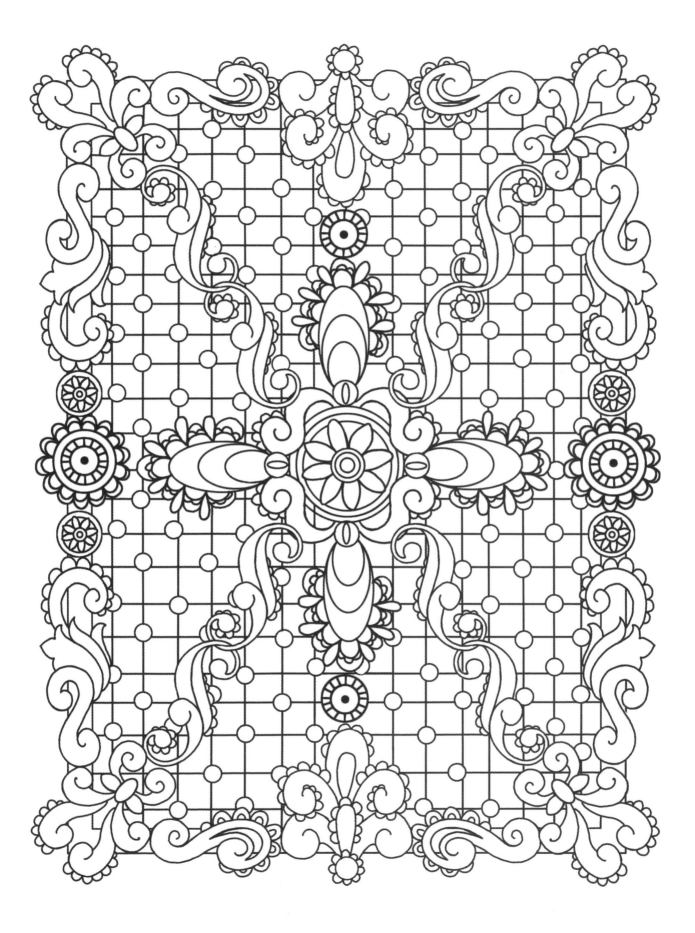

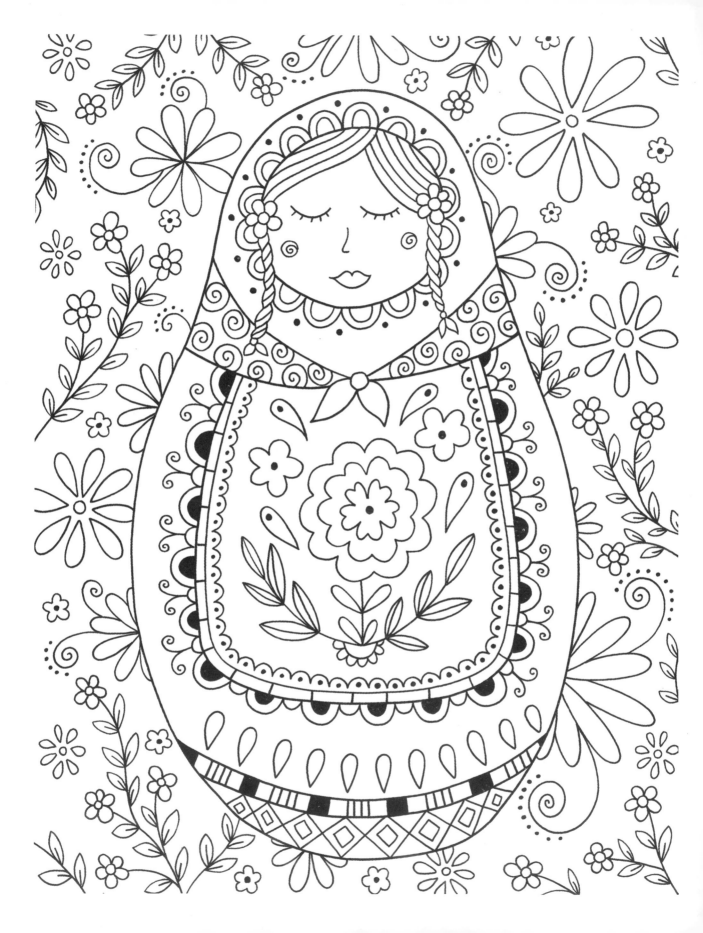

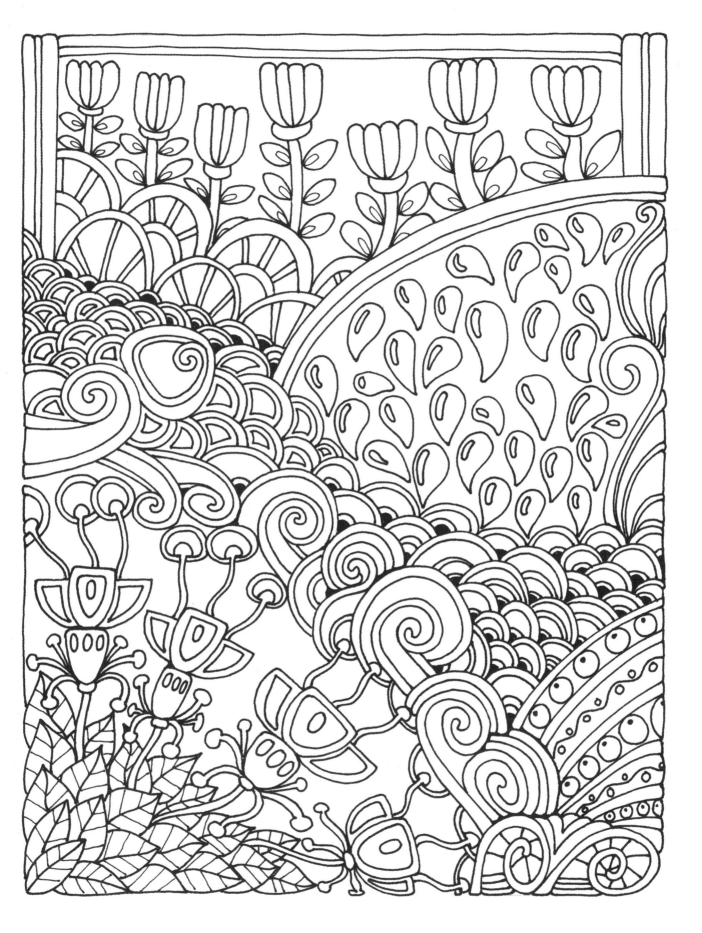

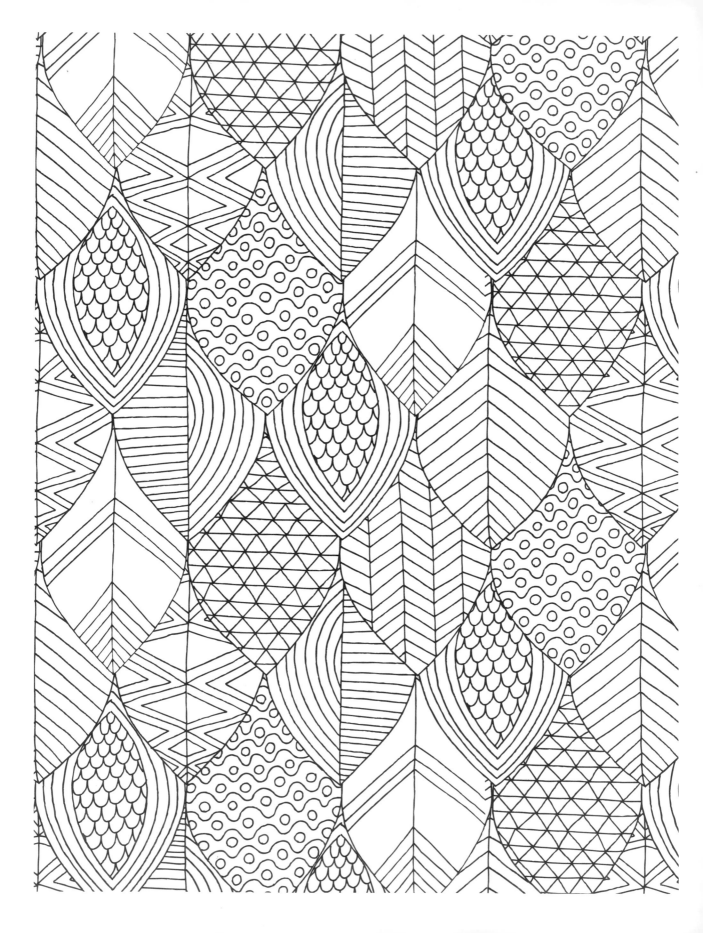

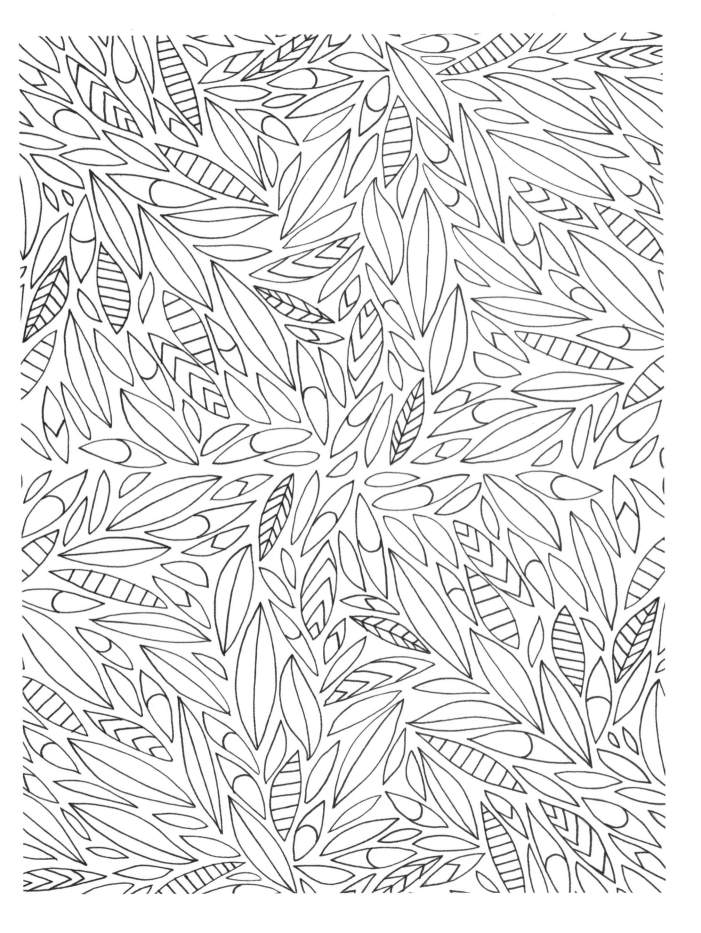

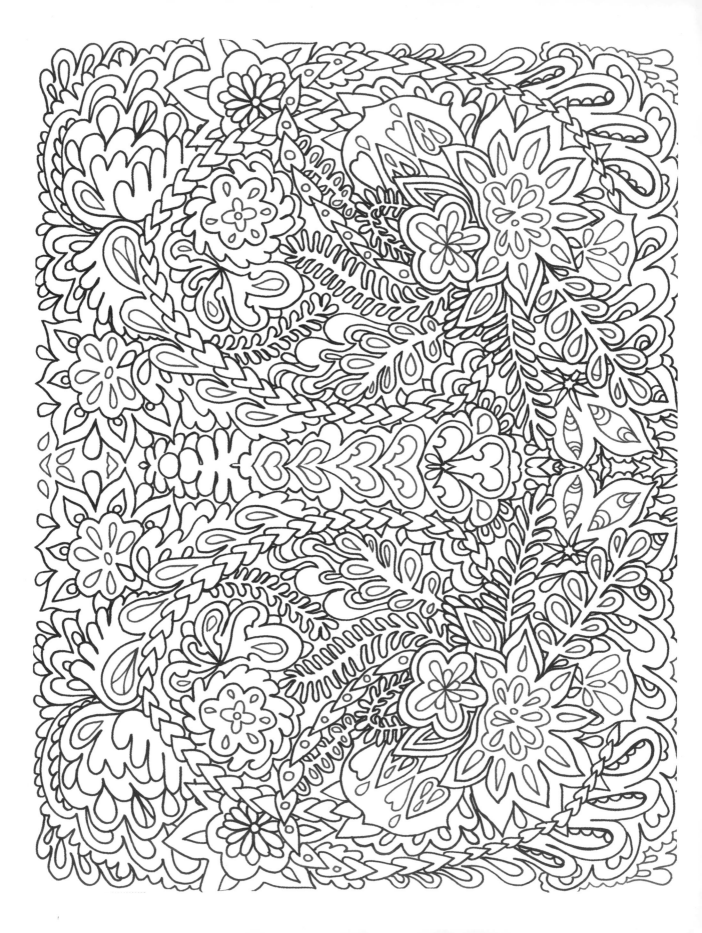

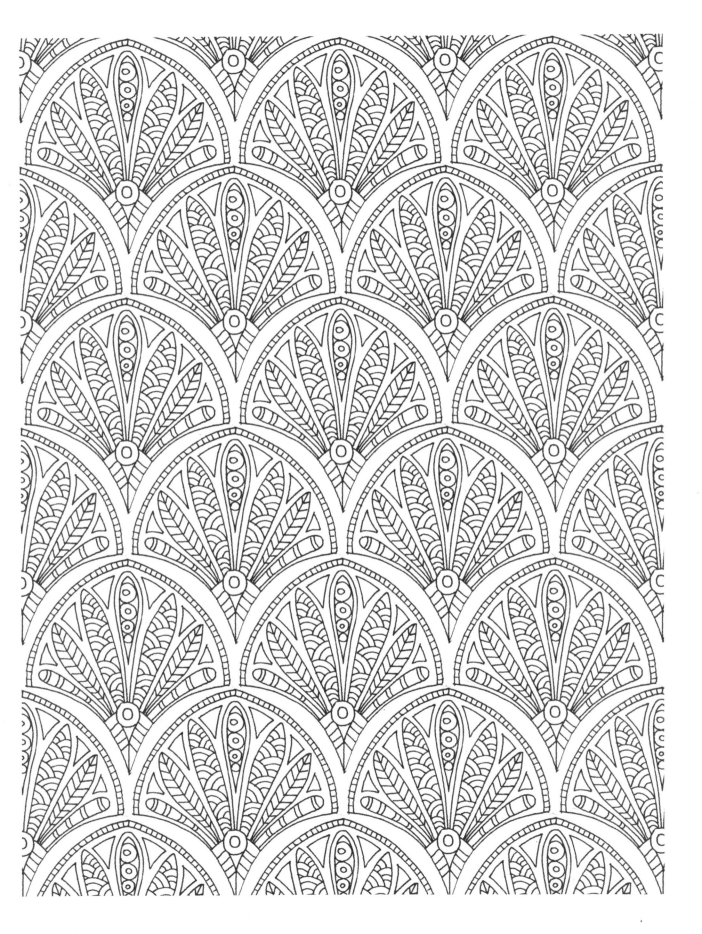

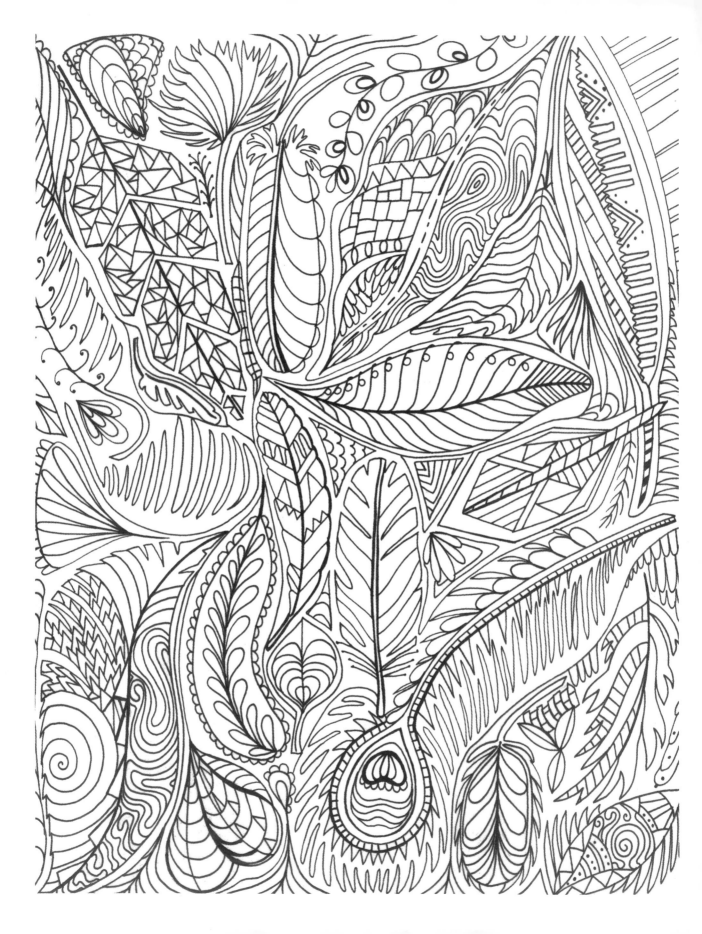

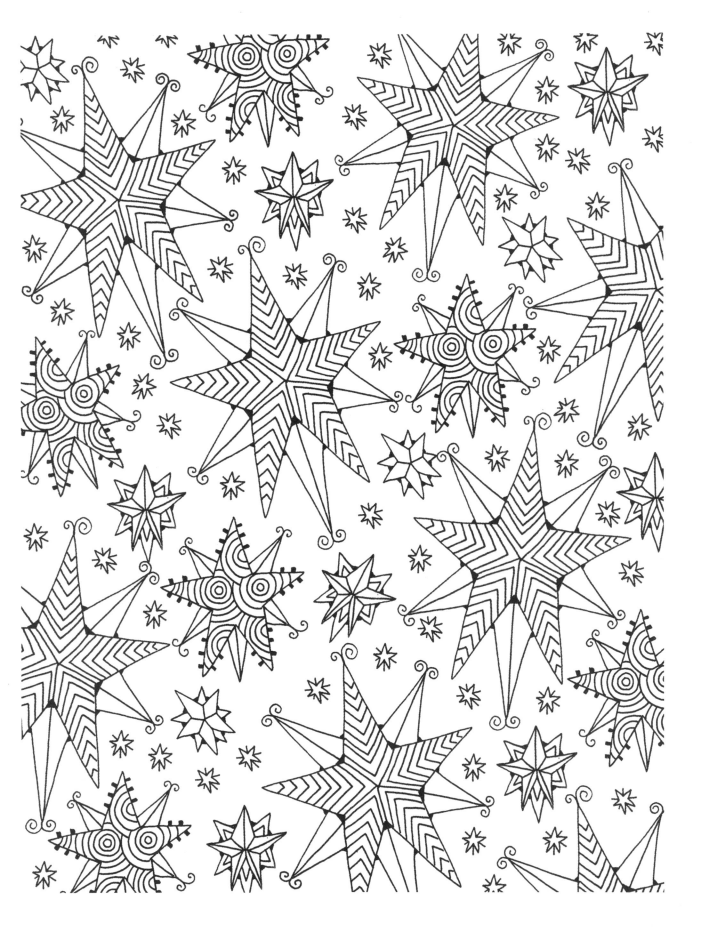

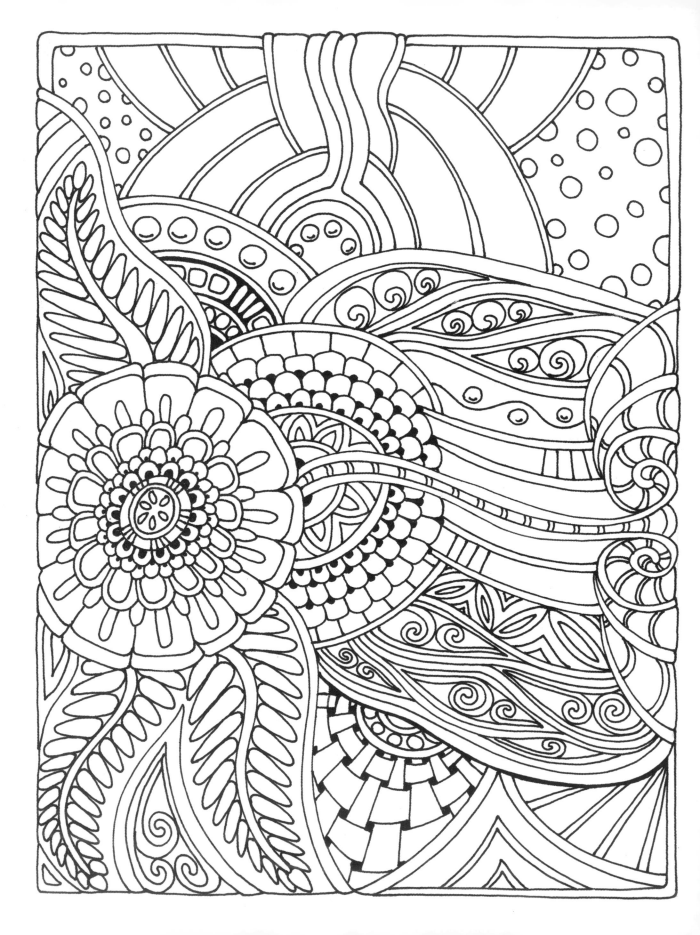

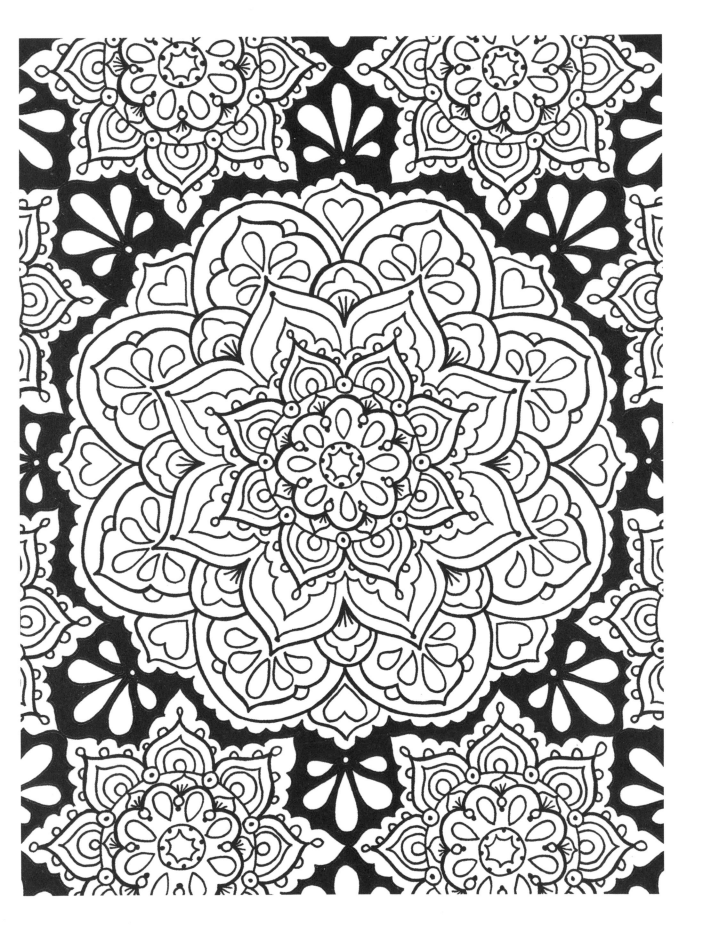

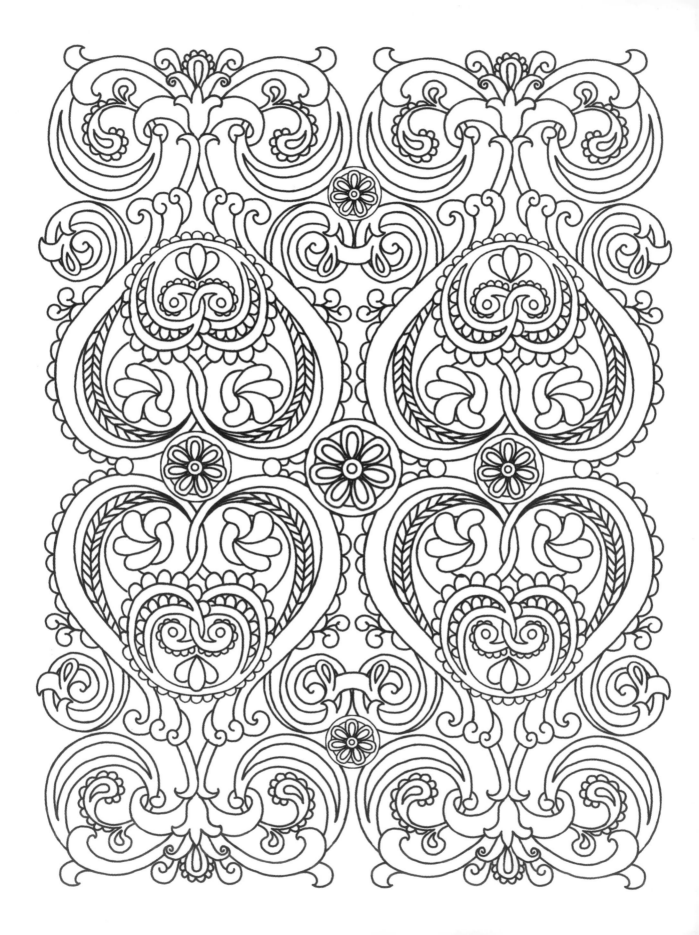

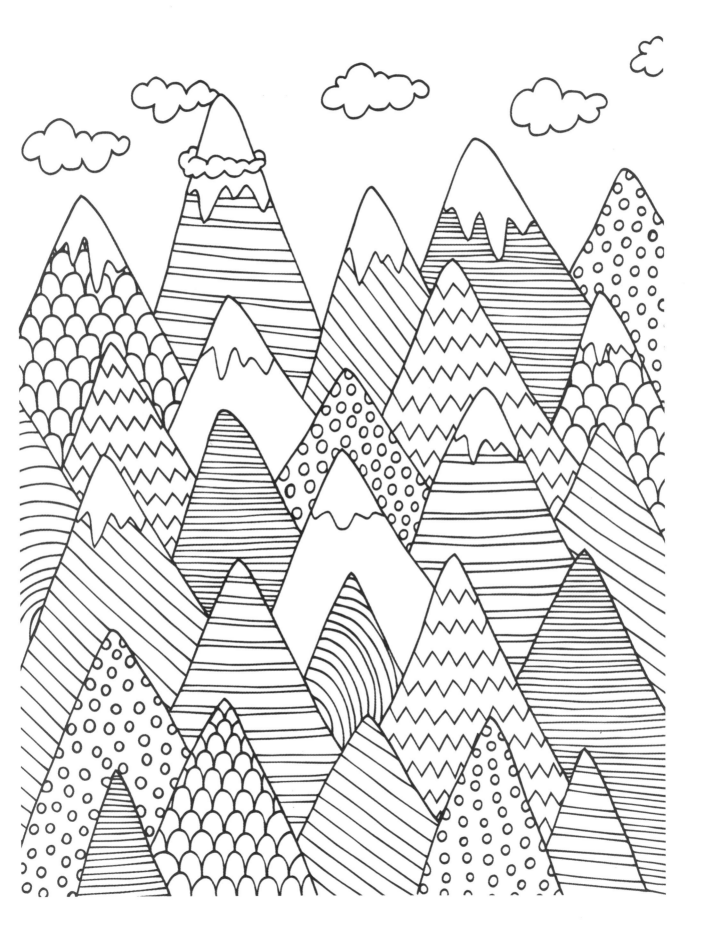

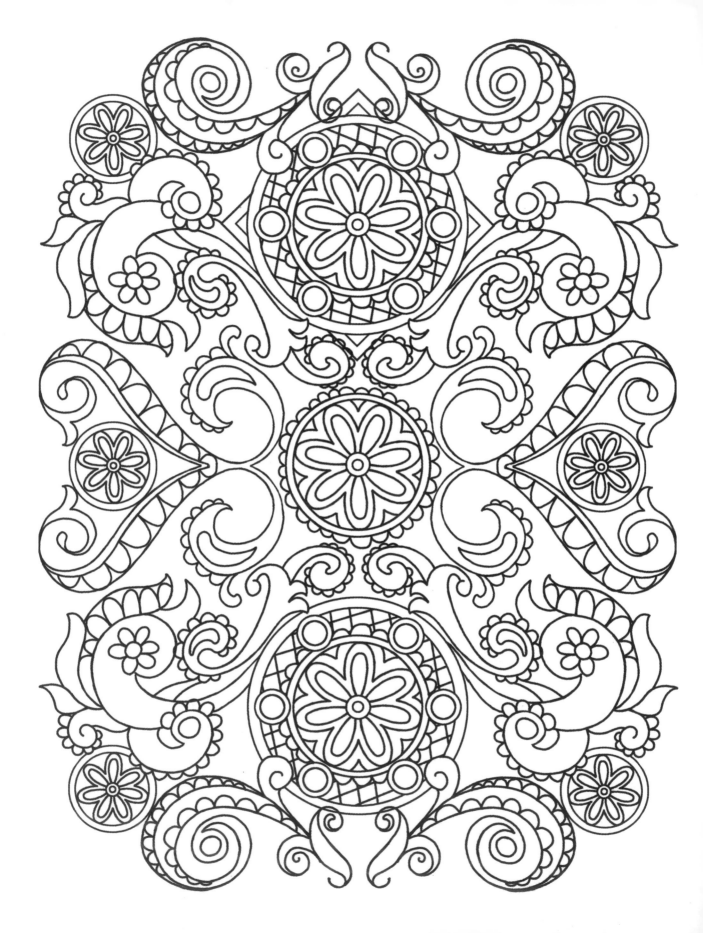

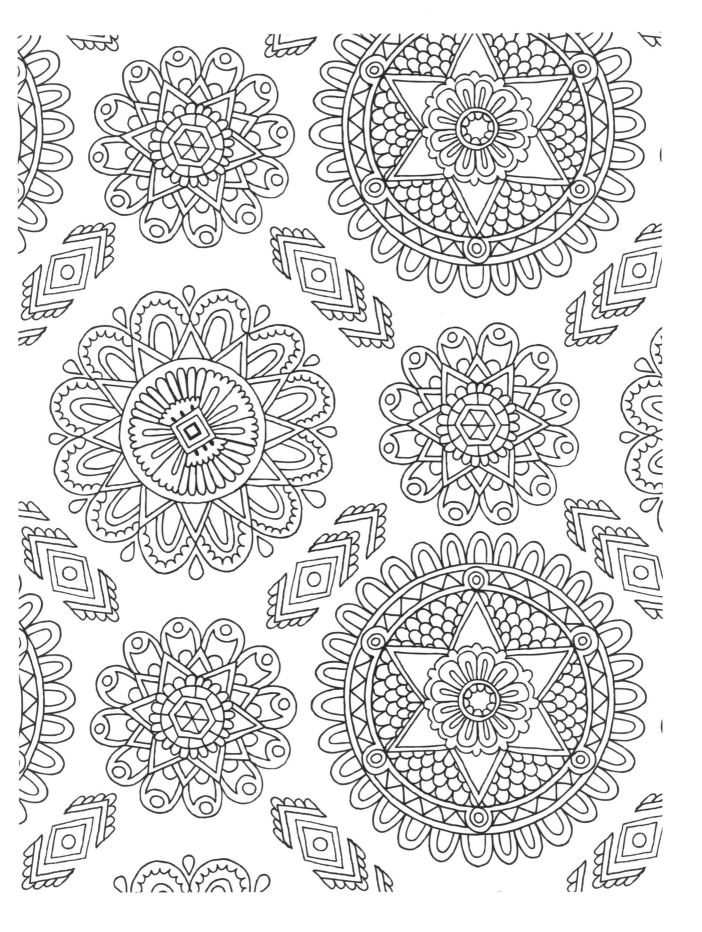

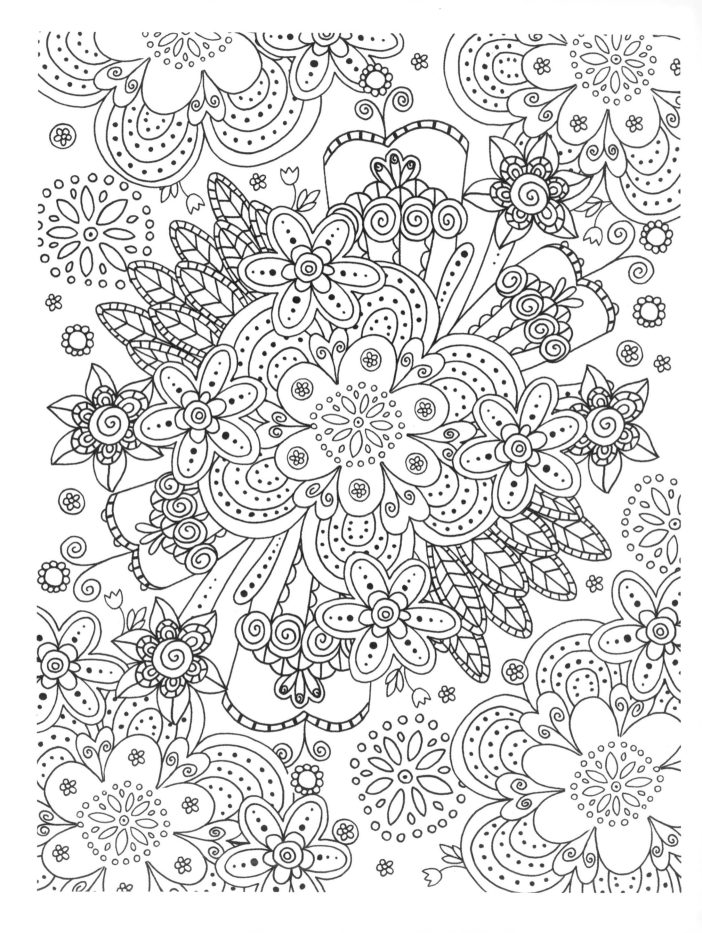

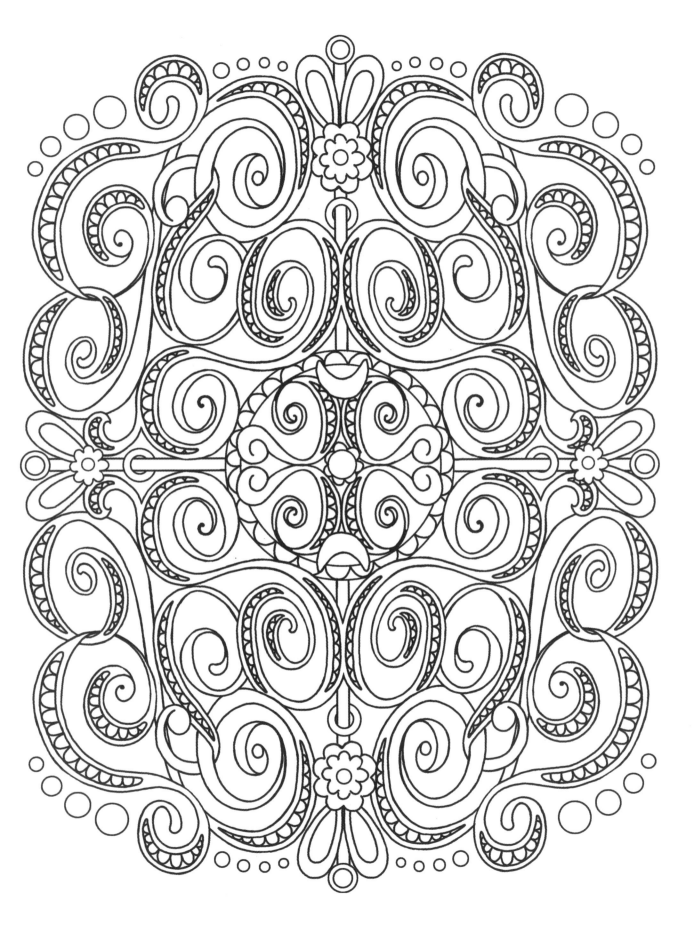

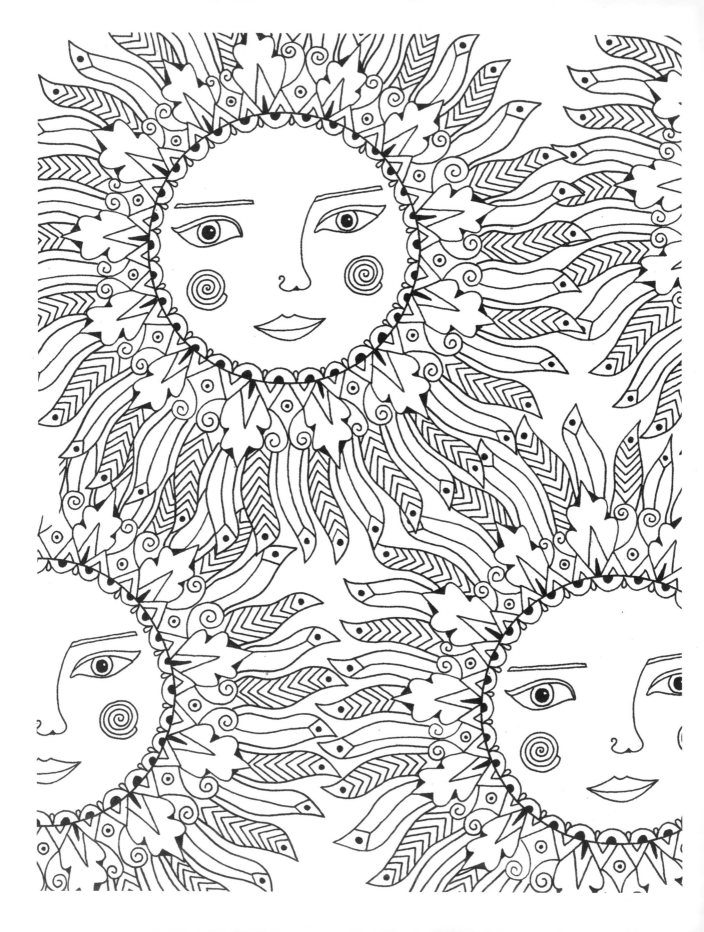

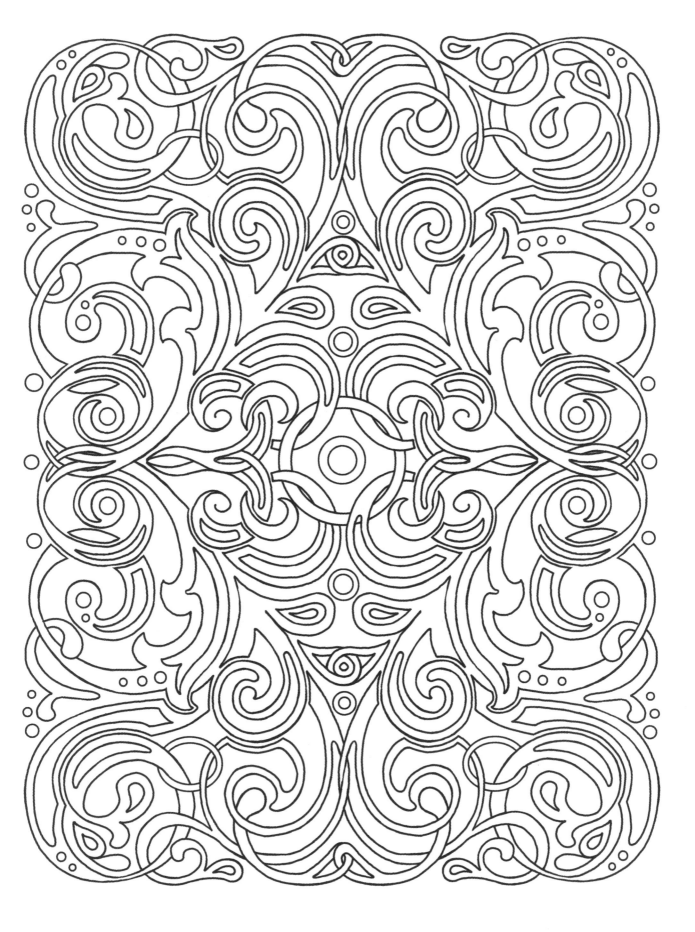

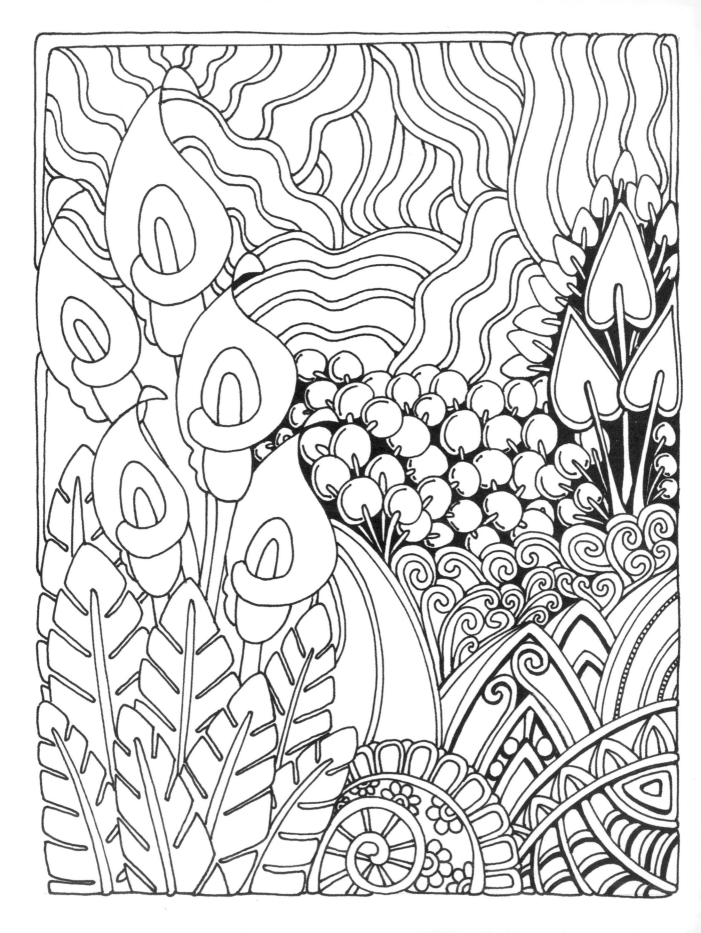

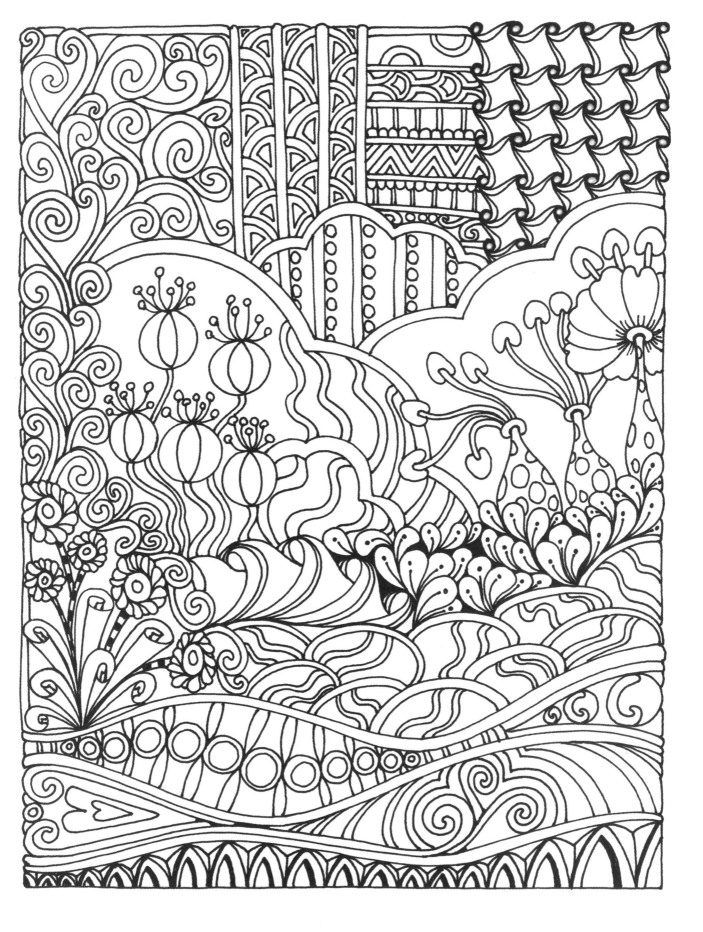

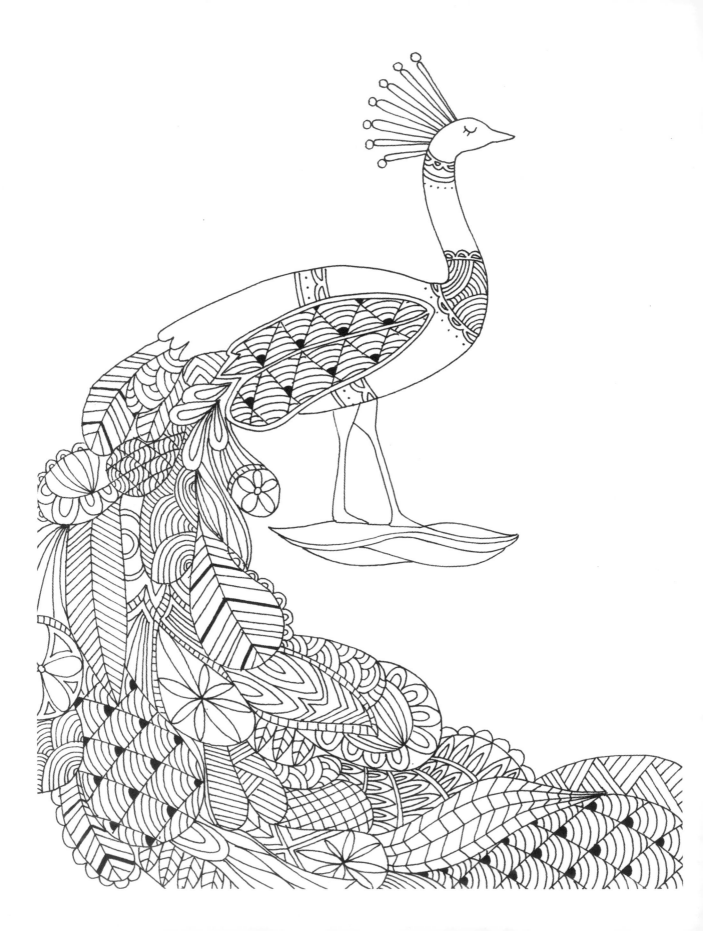

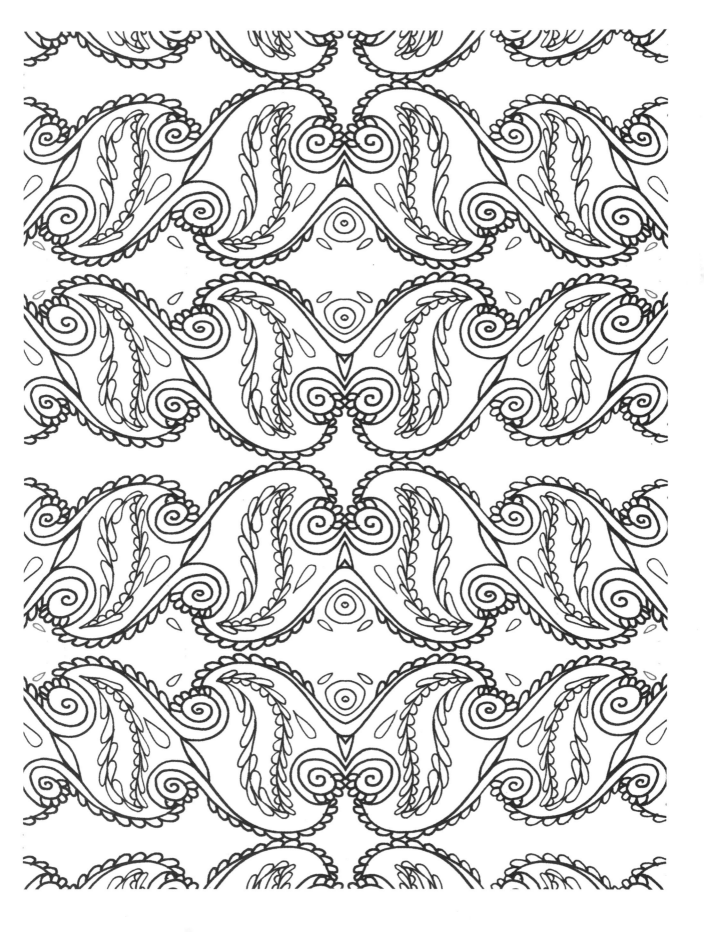

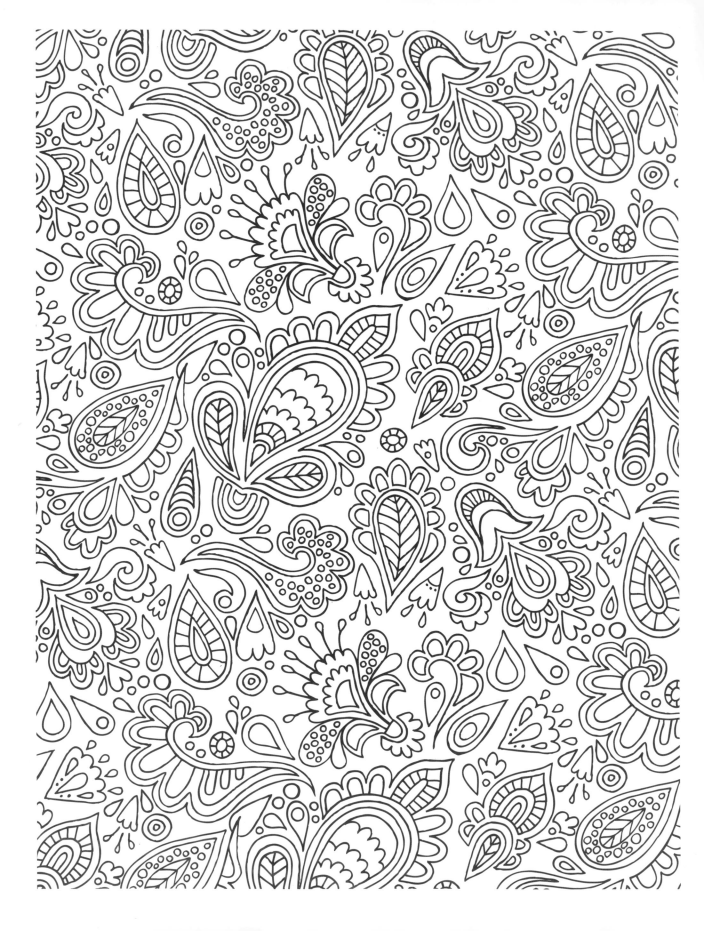

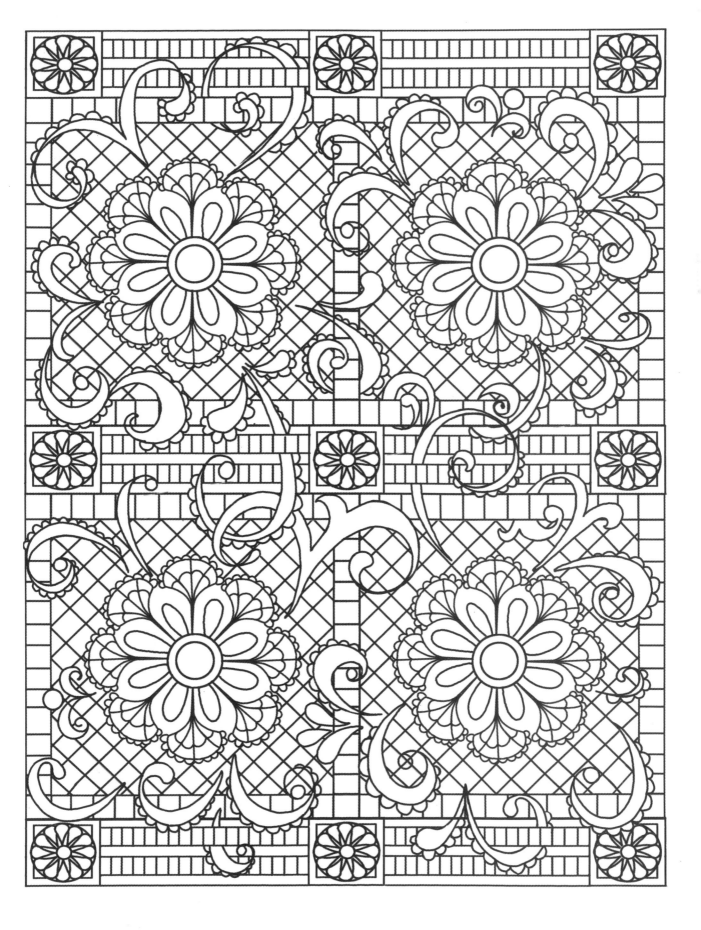

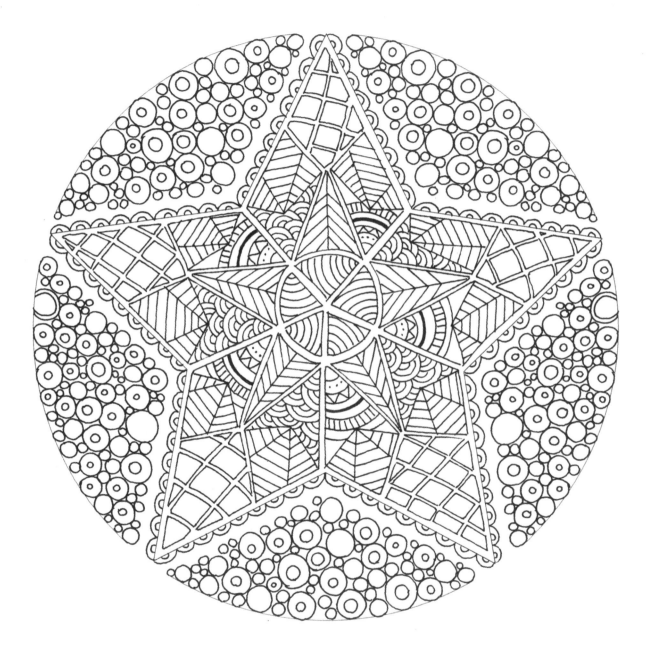

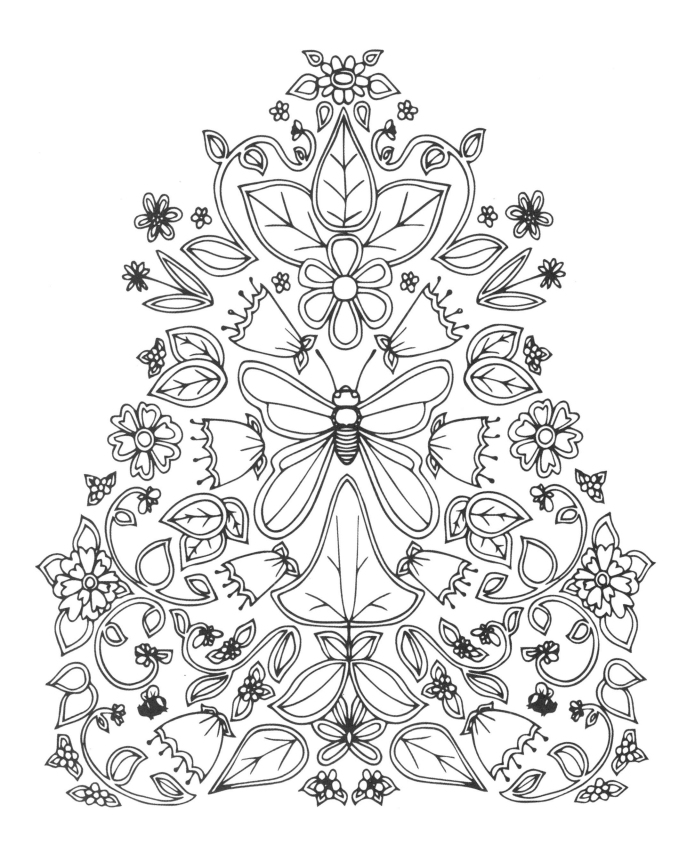

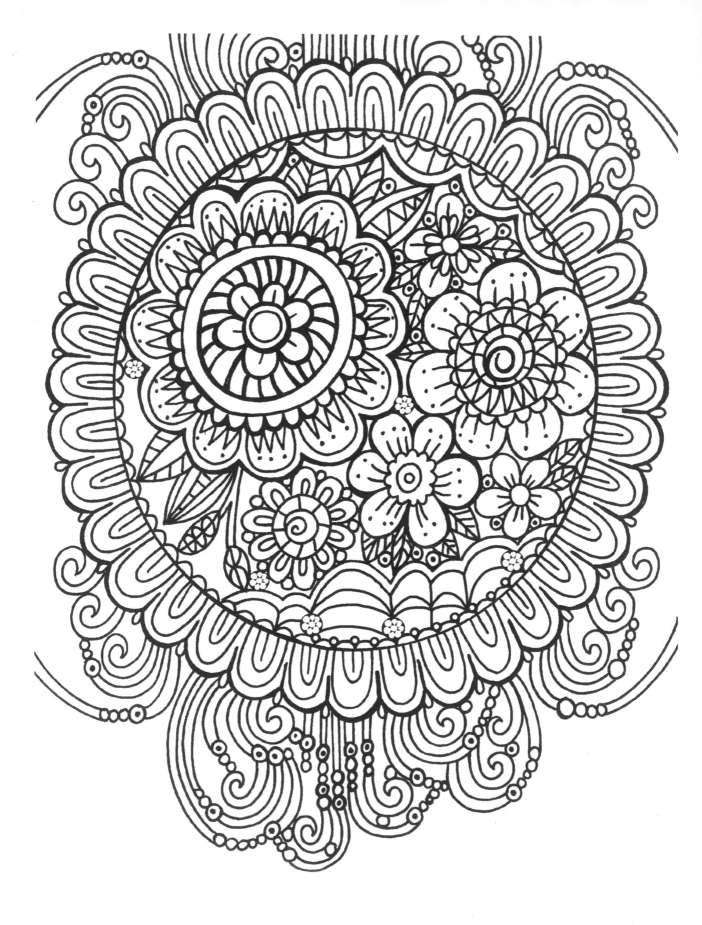

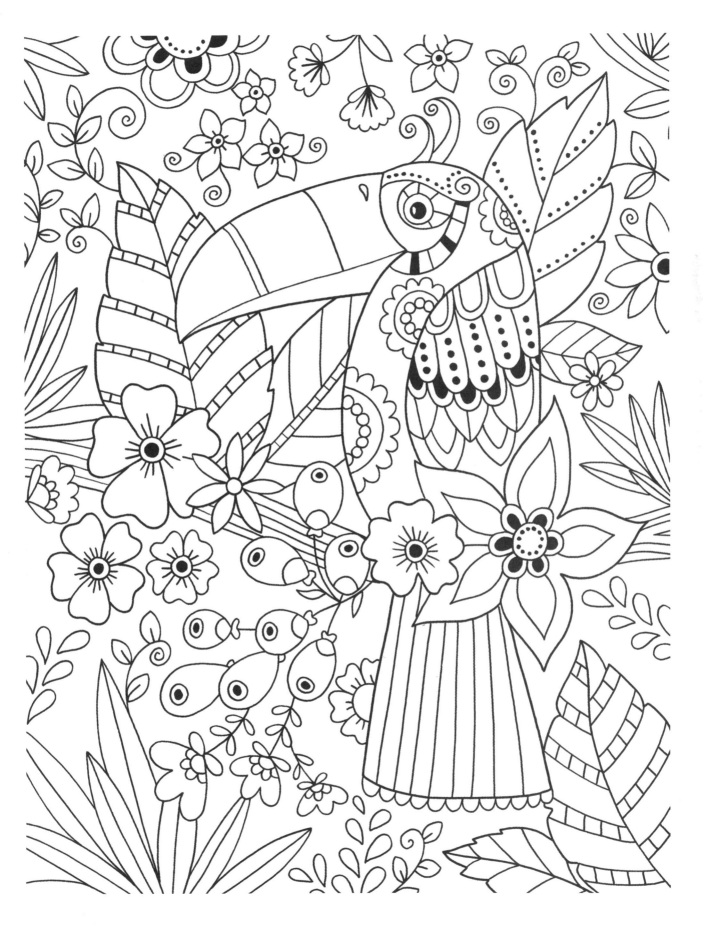

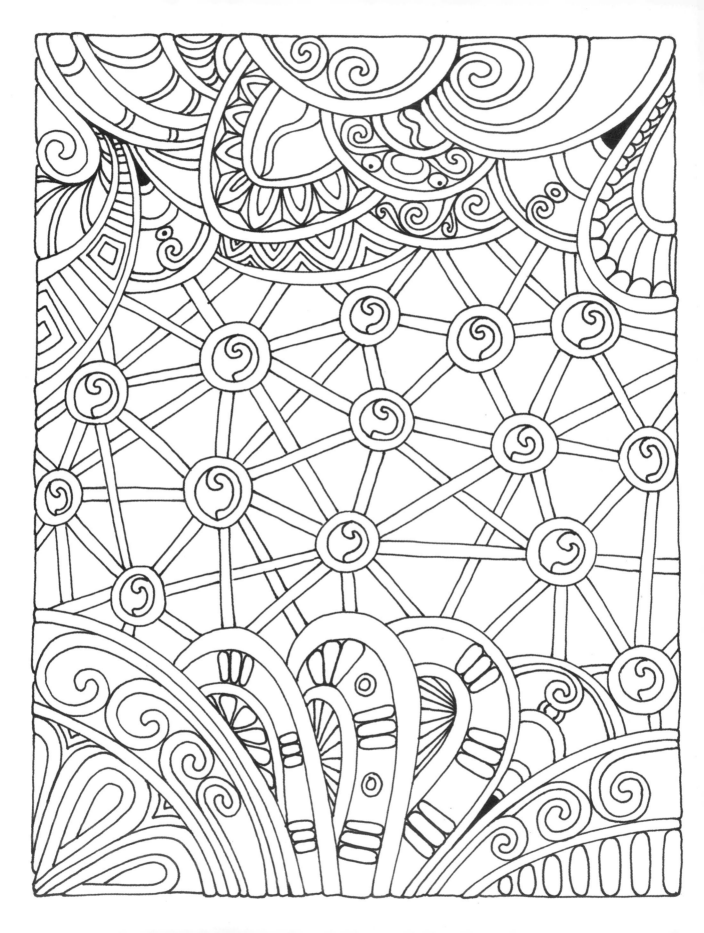

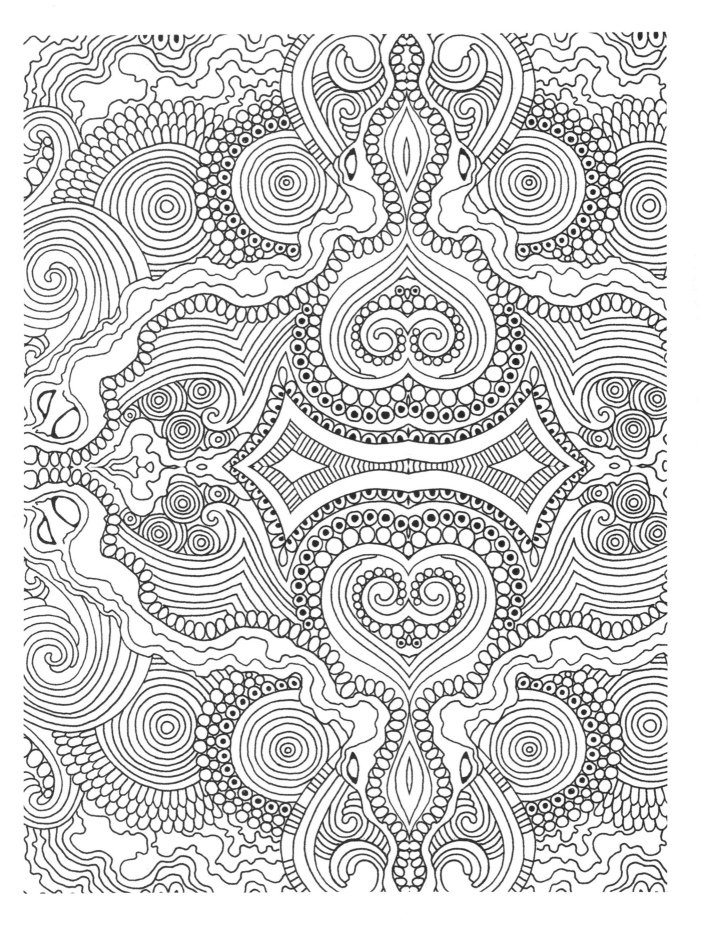

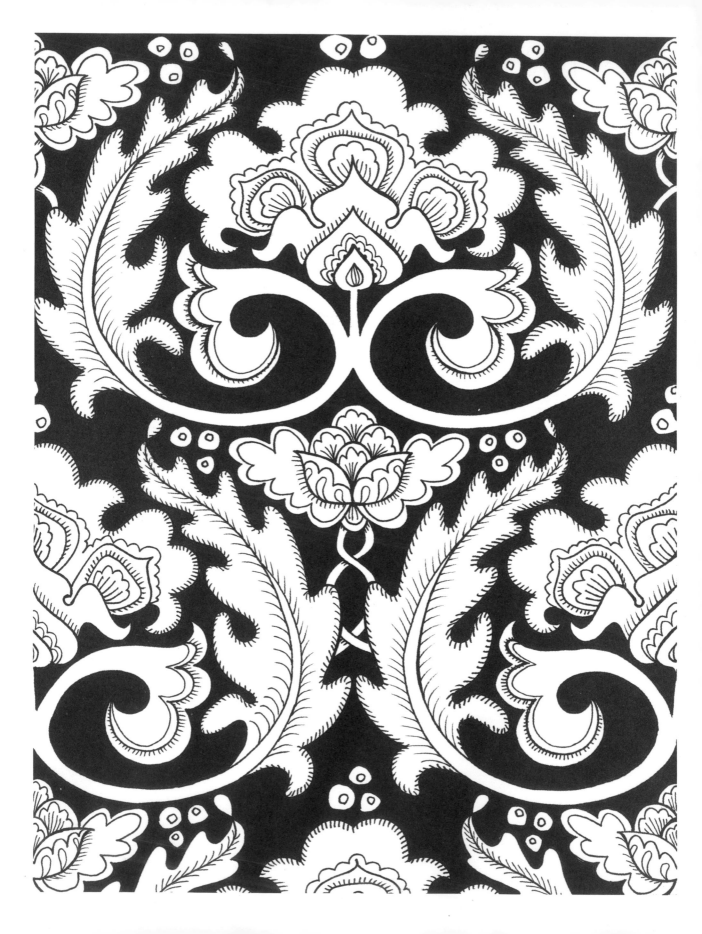

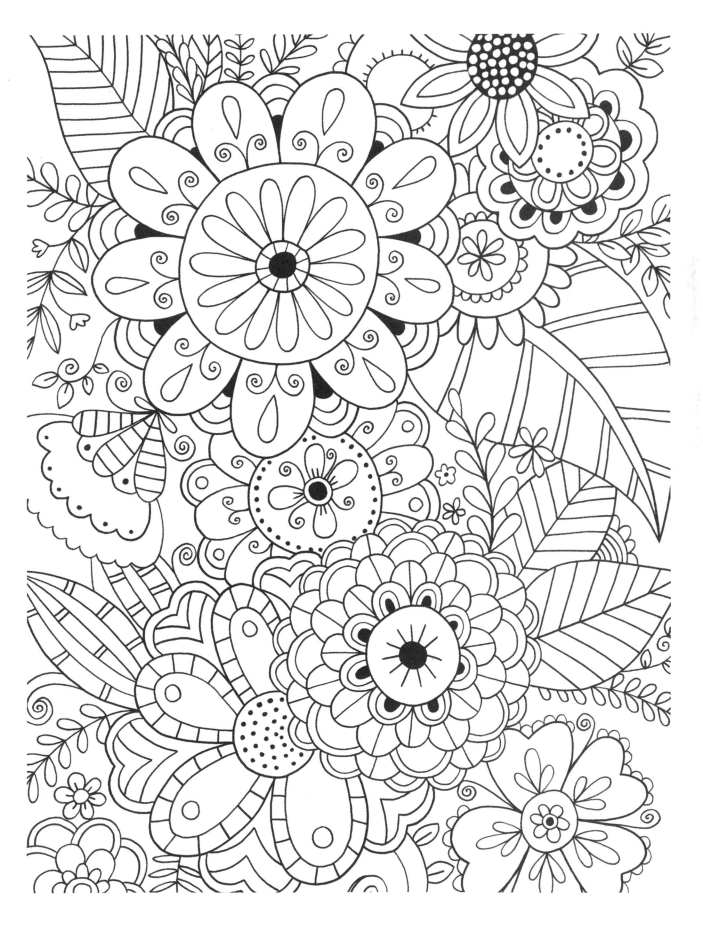

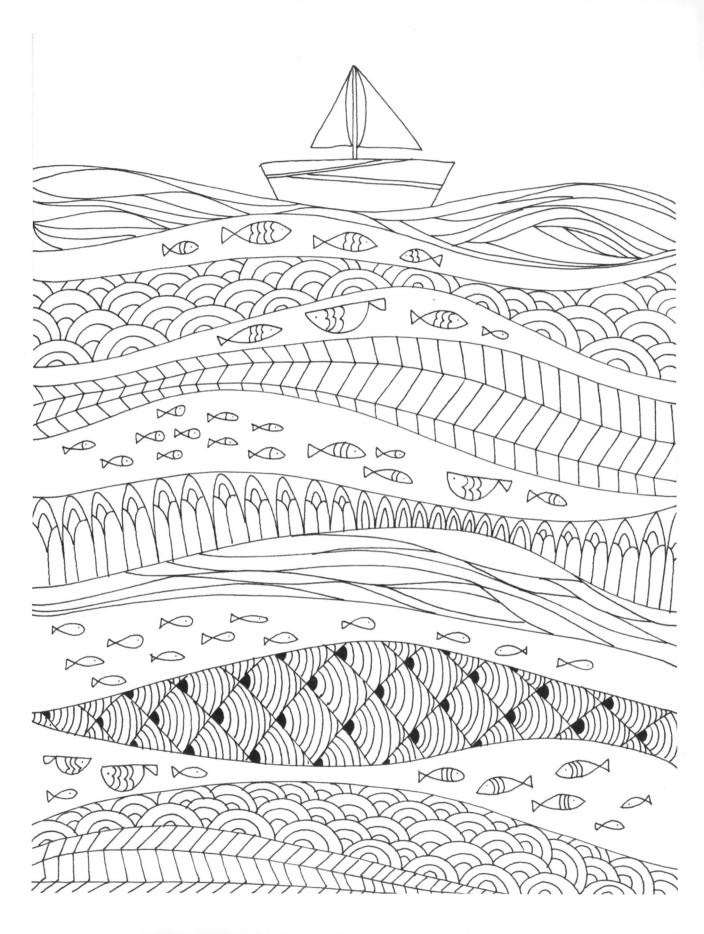

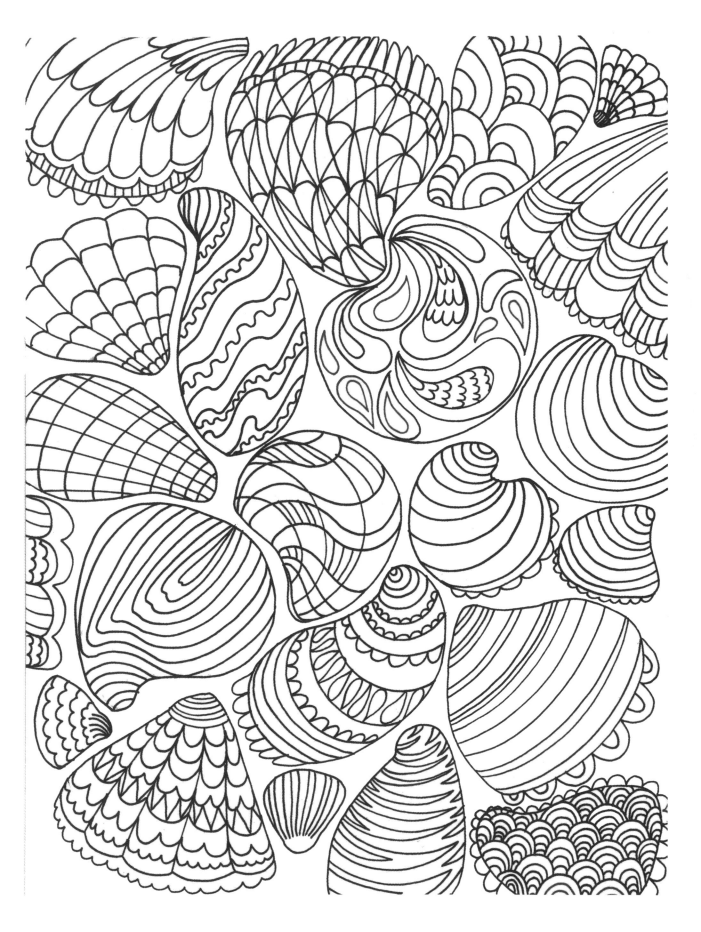

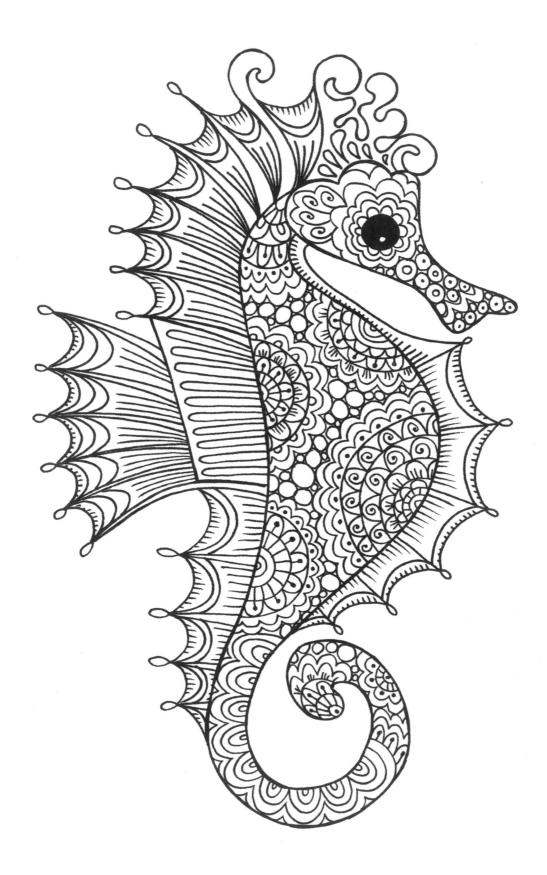

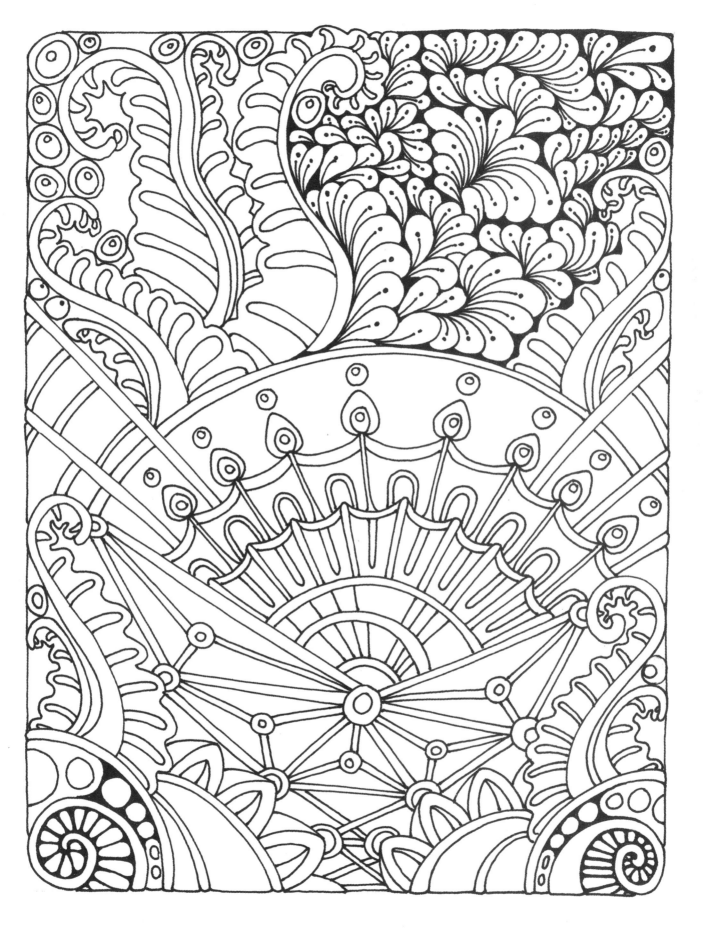

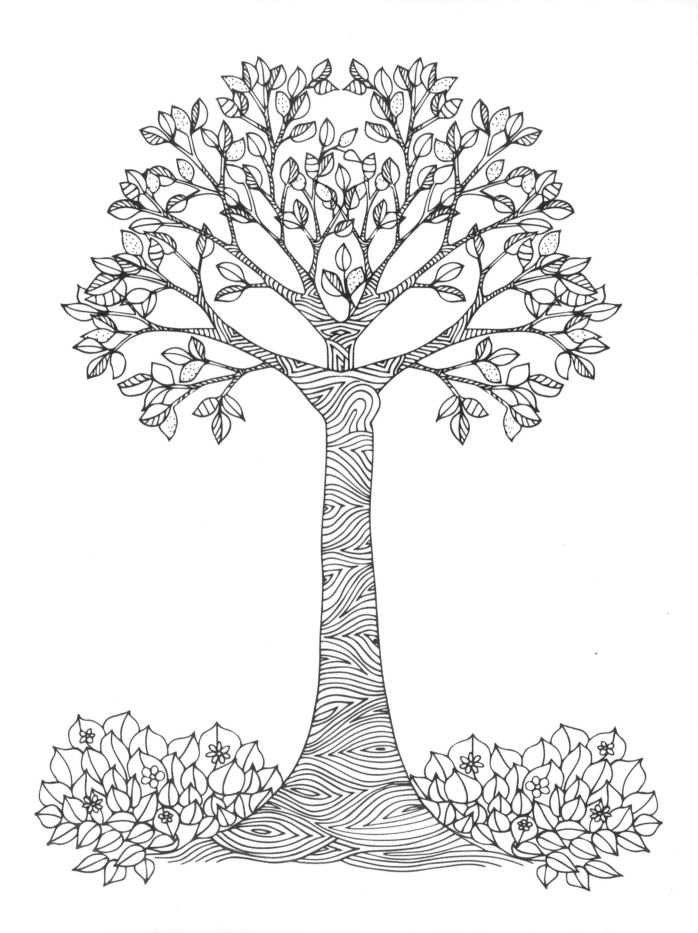

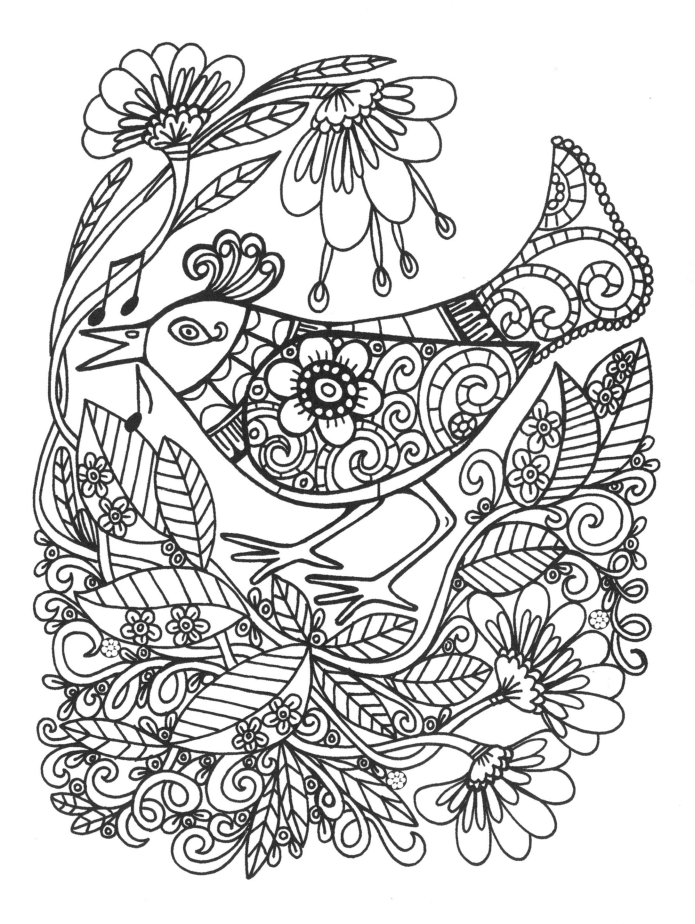

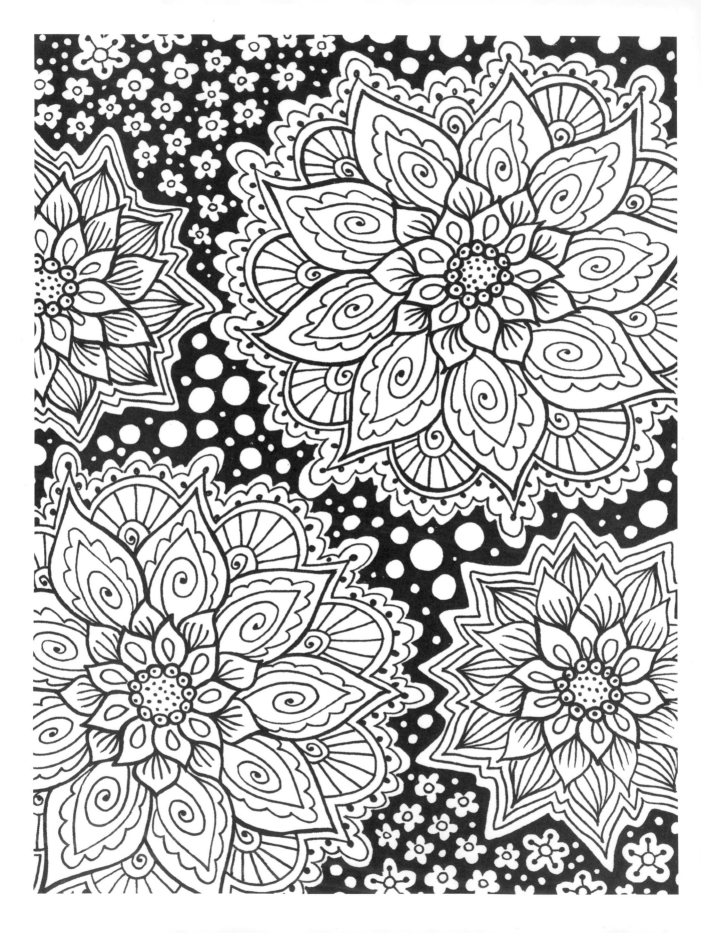

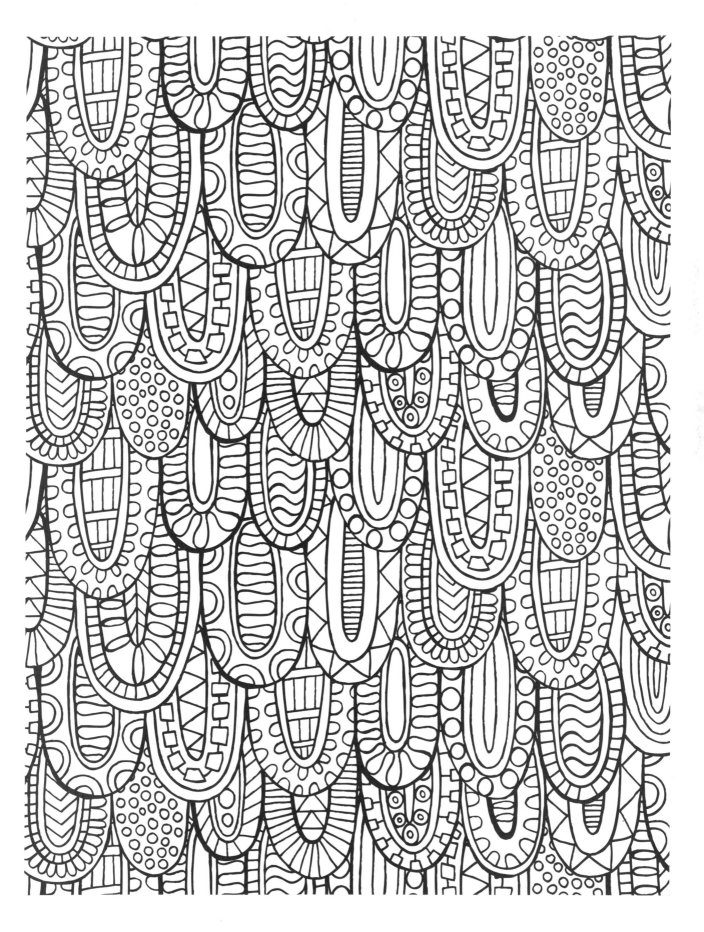

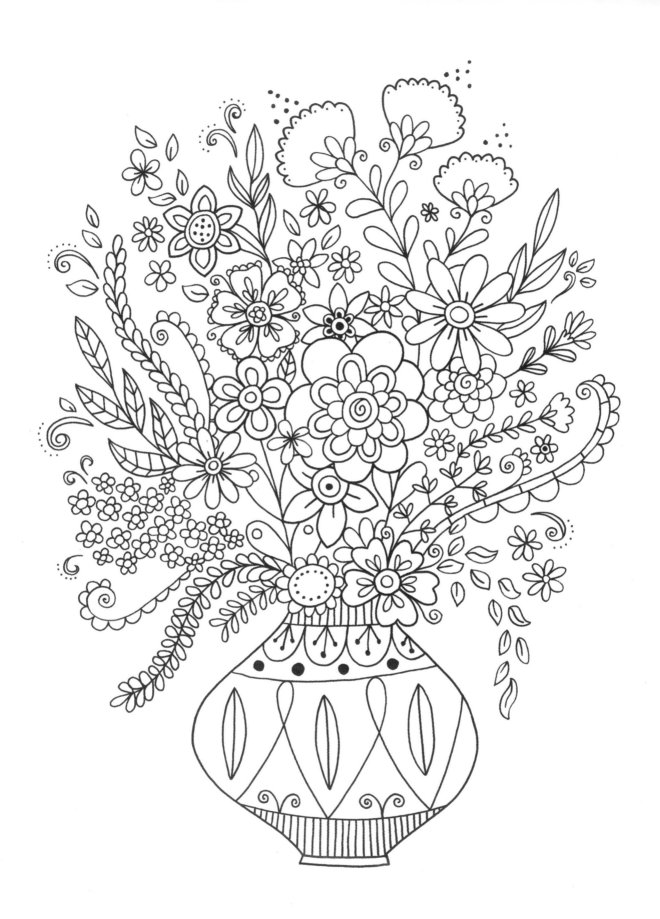

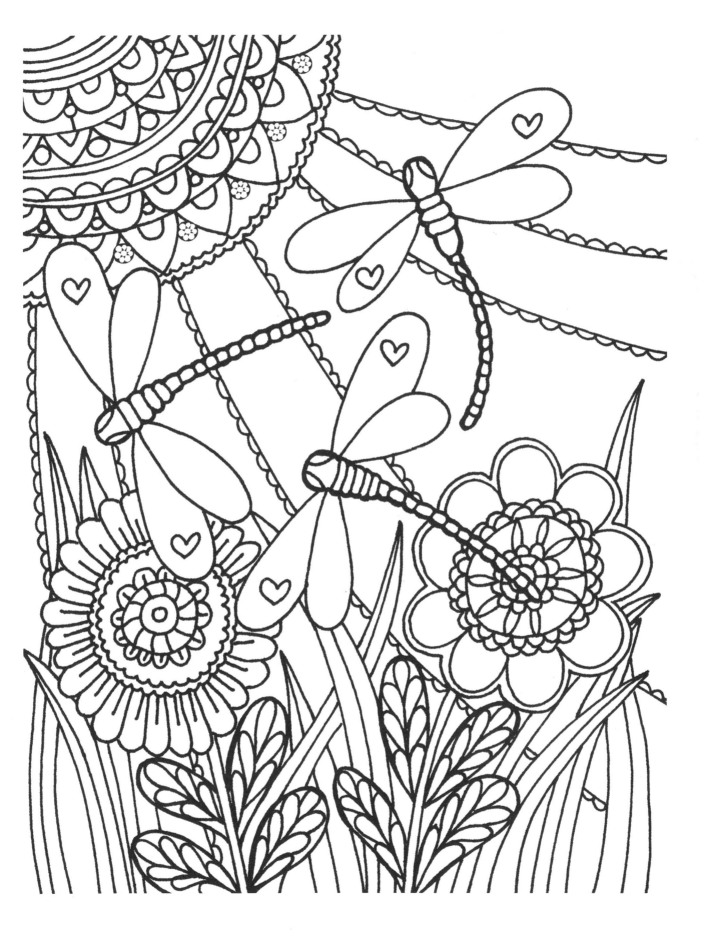

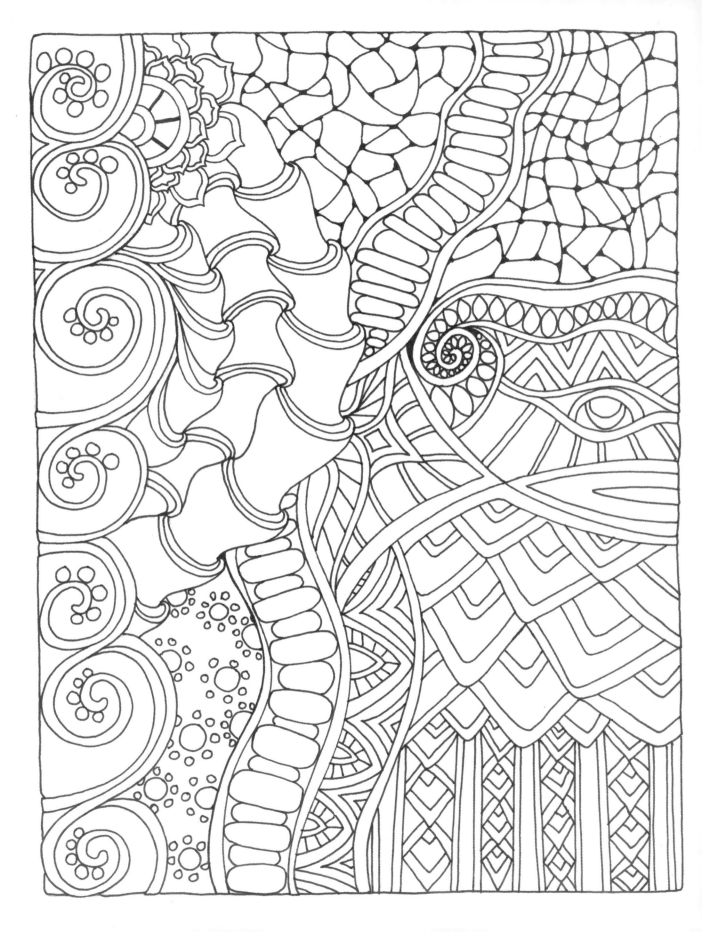

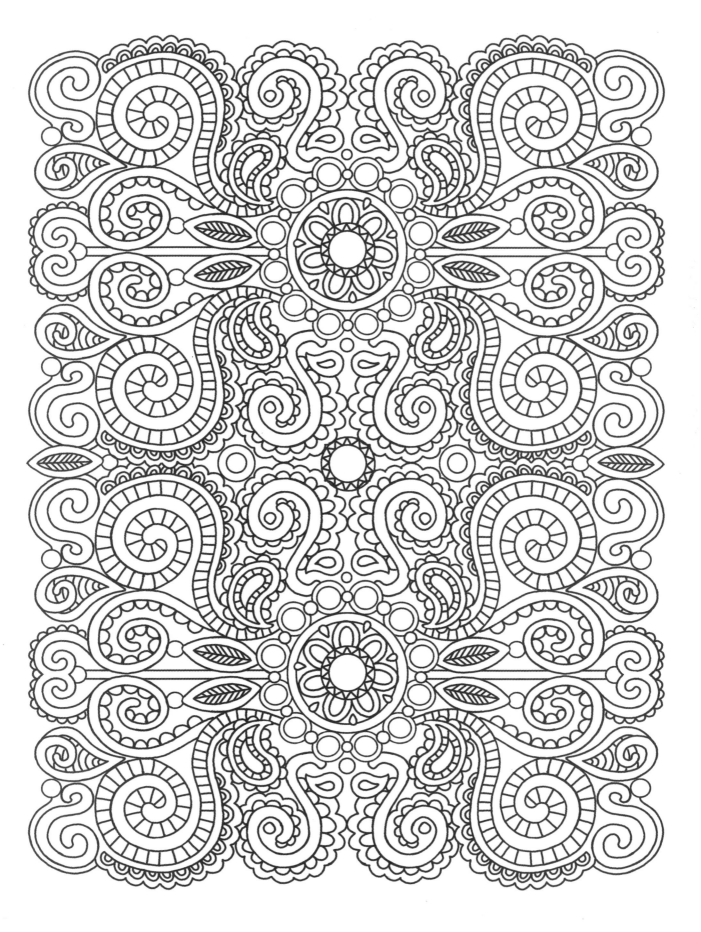

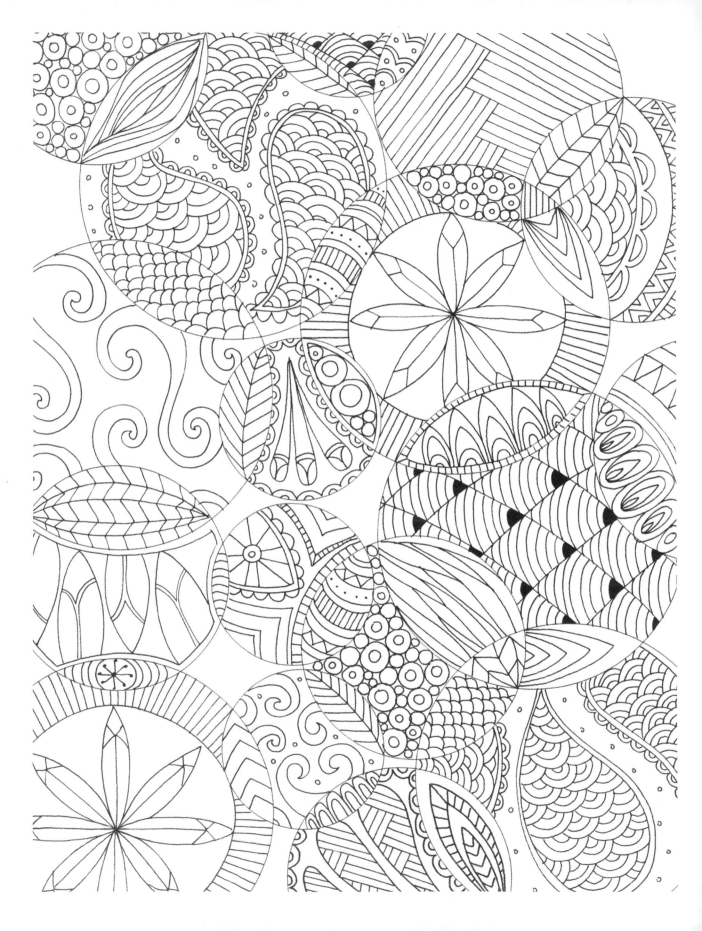

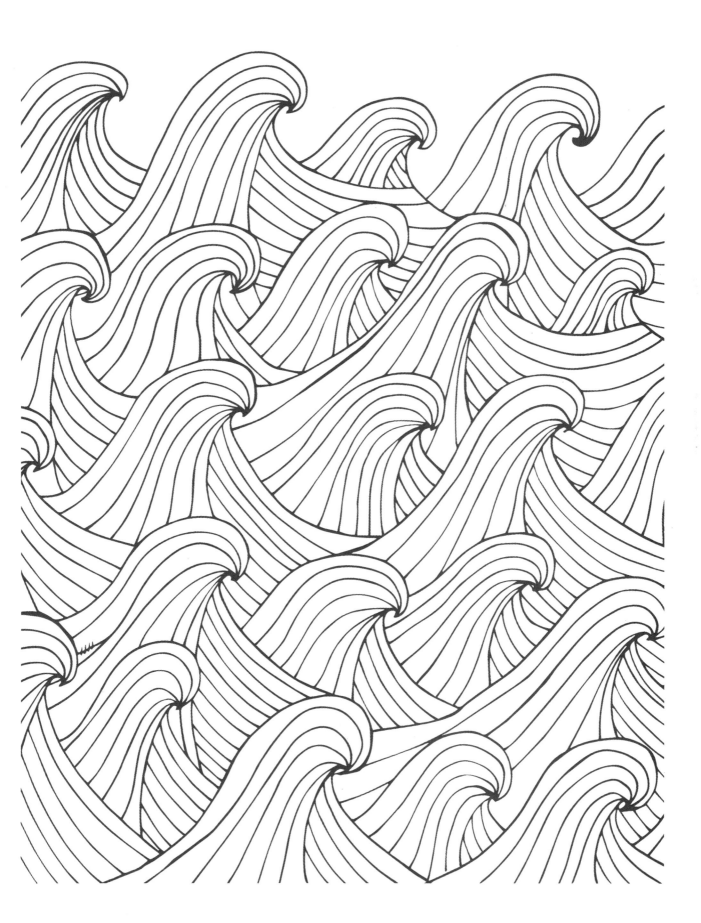

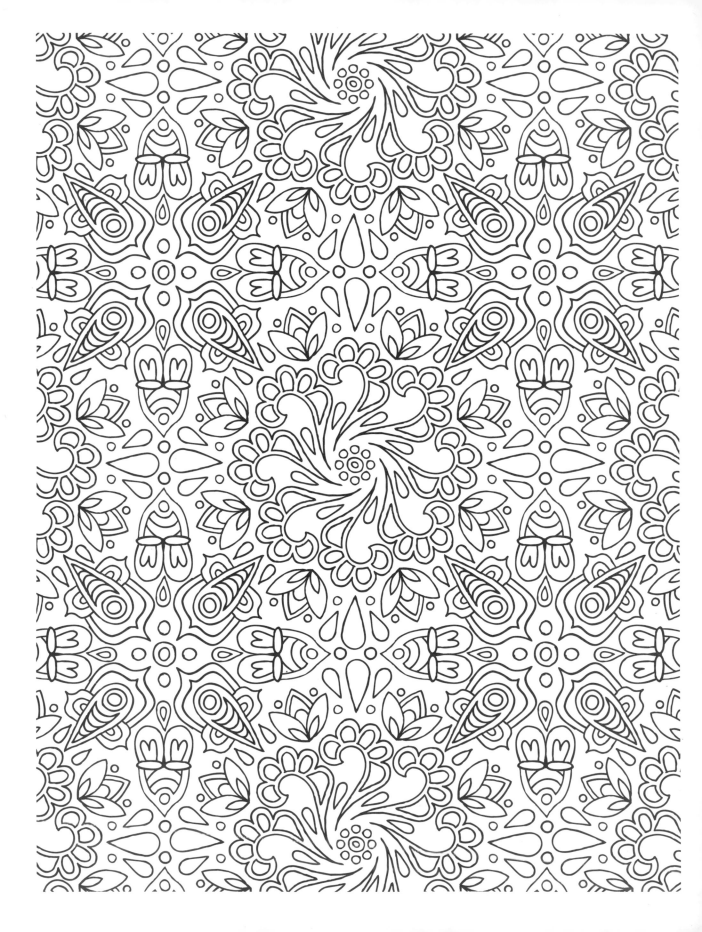

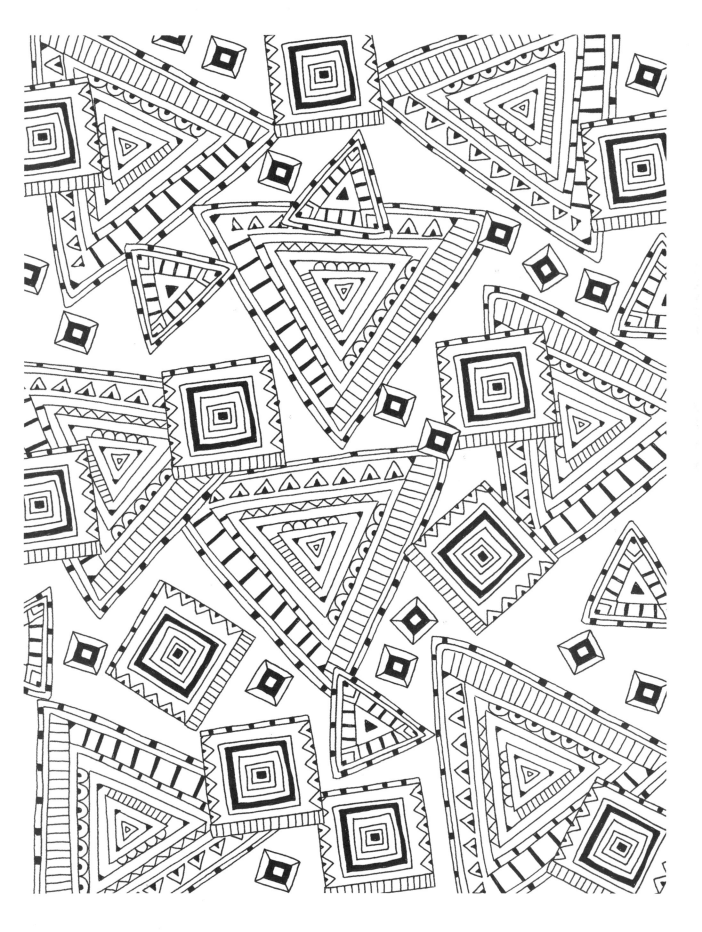

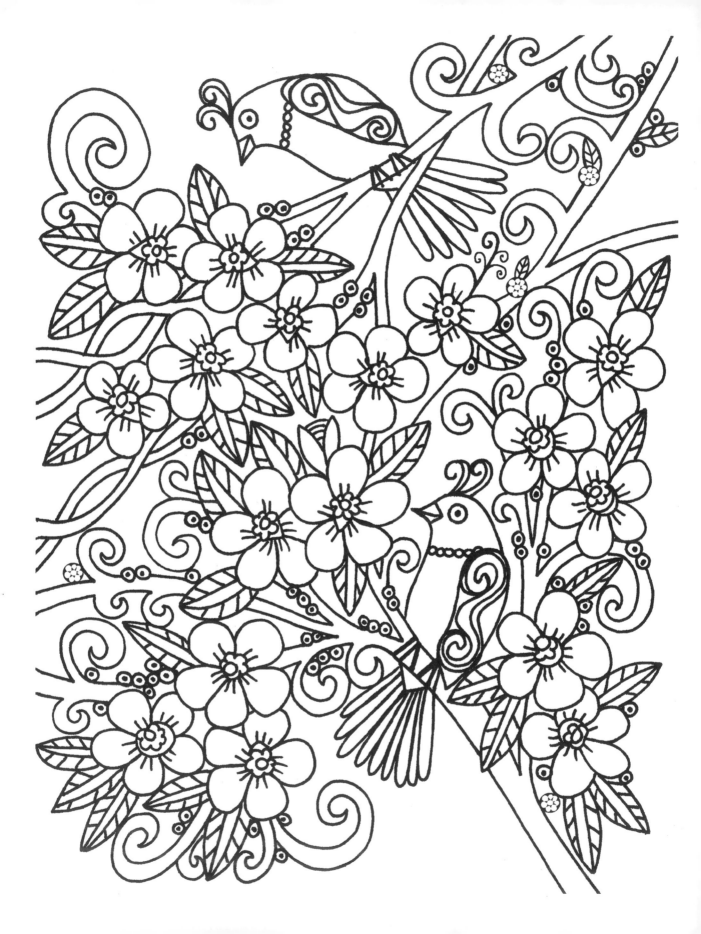

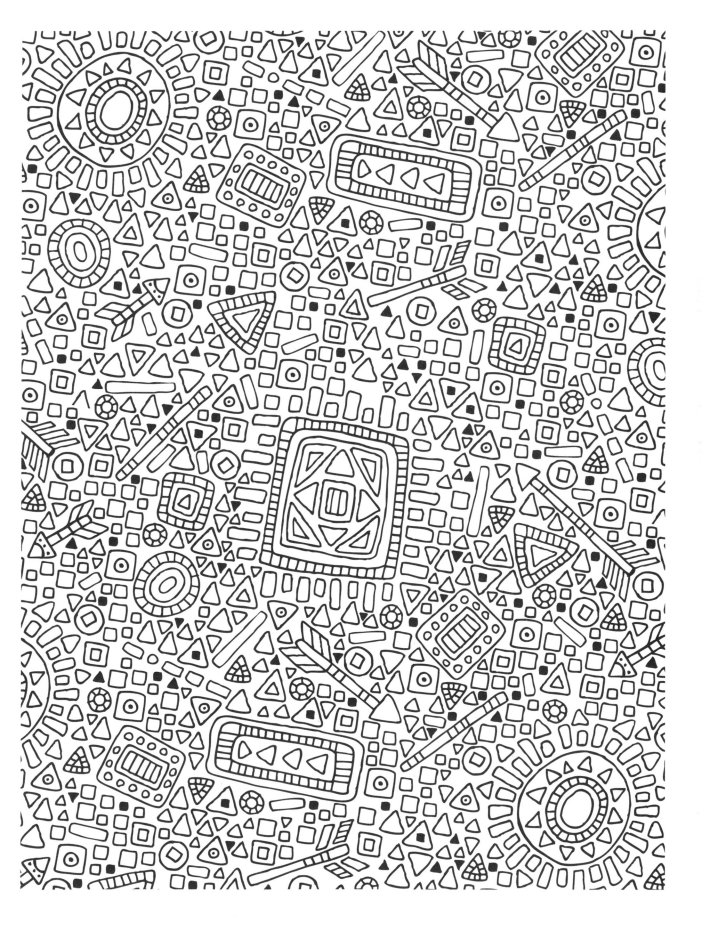

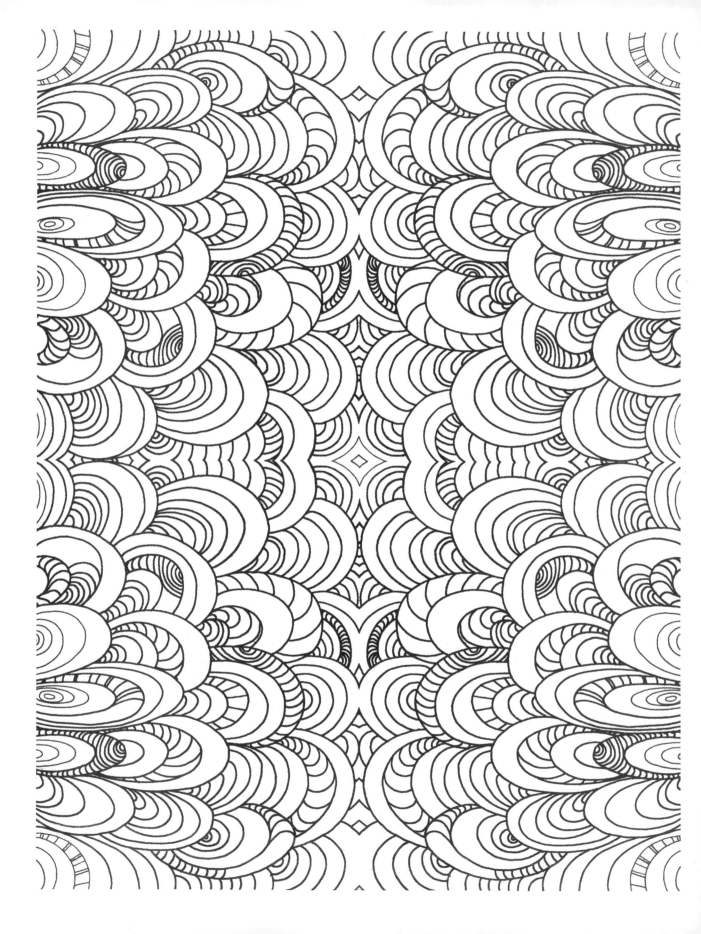

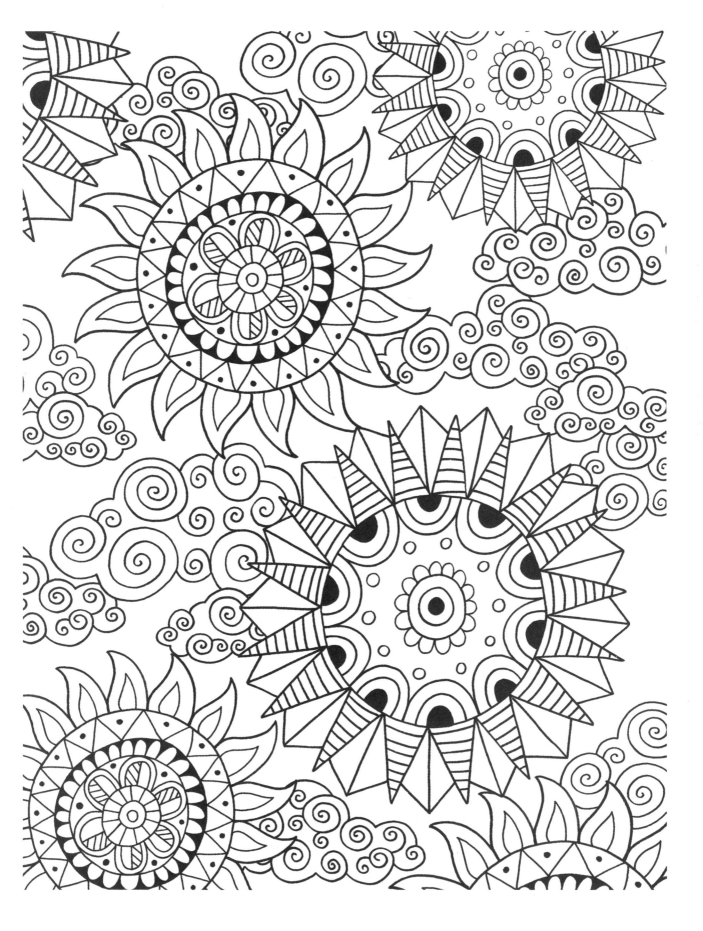

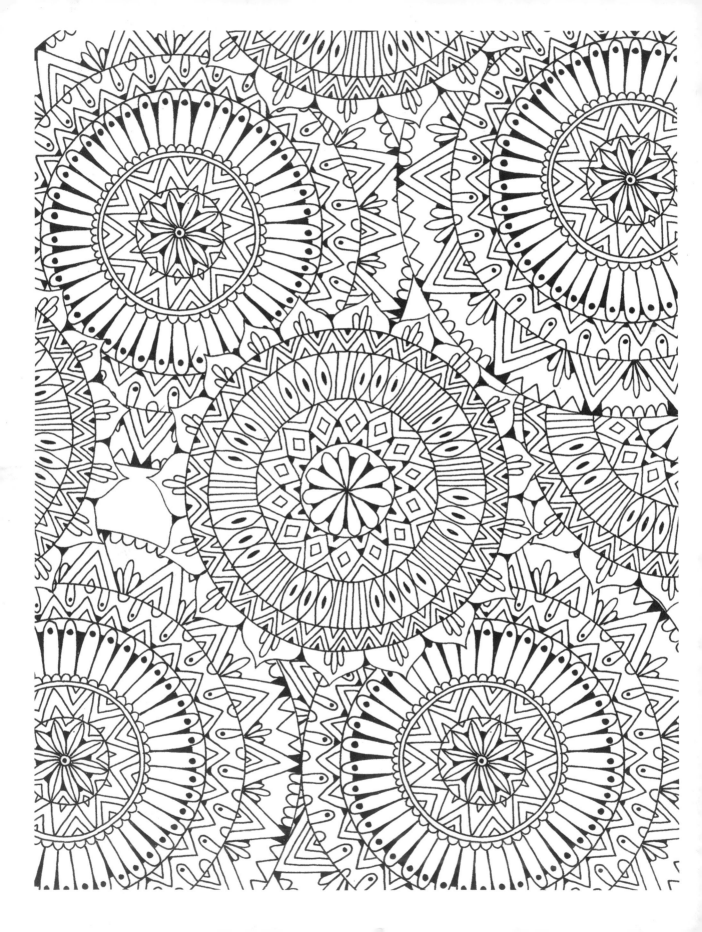